The New Silk Flower Book

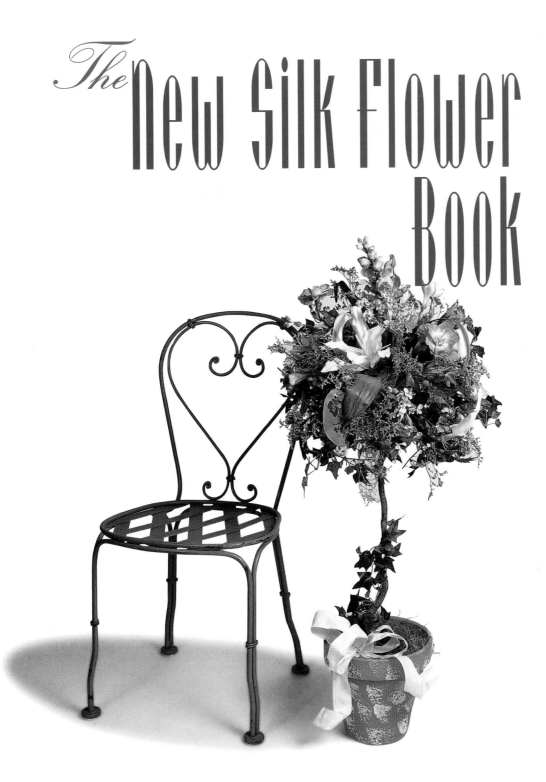

The New Silk Flower Book

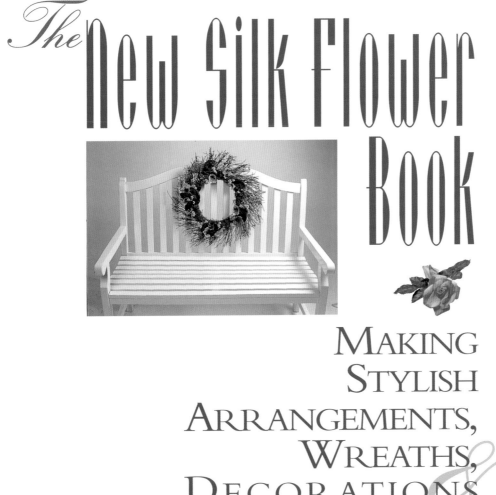

Making Stylish Arrangements, Wreaths, & Decorations

Laura Dover Doran

LARK BOOKS
A Division of
Sterling Publishing Co., Inc.
New York

Art Direction : Dana Irwin

Photography: Evan Bracken, Light Reflections

Production: Dana Irwin

Production Assistant: Bobby Gold

Doran, Laura Dover.

 The new silk flower book : making stylish arrangments, wreaths, and decorations / Laura Dover Doran.

 p. cm.

 Includes index.

 ISBN: 1-57990-010-0 (paper); 1-887374-41-8 (hard)

 1. Silk flowers. 2. Flower arrangements. 3. Wreaths. I. Title.

TT890.7.D67 1997 97-3614

745.594'3--dc21 CIP

10 9 8 7 6 5 4

Published by Lark Books, a division of
Sterling Publishing Co., Inc.
387 Park Avenue South, New York, N.Y. 10016

©1997, Lark Books

Distributed in Canada by Sterling Publishing,
c/o Canadian Manda Group, One Atlantic Ave., Suite 105
Toronto, Ontario, Canada M6K 3E7

Distributed in the U.K. by:
Guild of Master Craftsman Publications Ltd.
Castle Place, 166 High Street, Lewes East Sussex, England BN7 1XU
Tel: (+ 44) 1273 477374, Fax: (+ 44) 1273 478606,
Email: pubs@thegmcgroup.com, Web: www.gmcpublications.com

Distributed in Australia by Capricorn Link (Australia) Pty Ltd., P.O. Box 704, Windsor, NSW 2756 Australia

If you have questions or comments about this book, please contact:
Lark Books
50 College St.
Asheville, NC 28801
(828) 253-0467

Printed in China

ISBN 1-57990-010-0

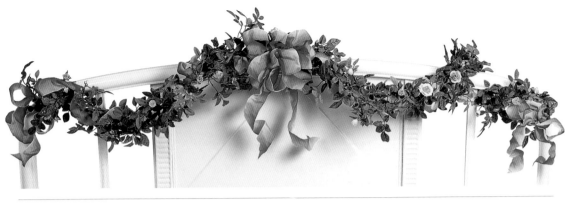

C O N T E N T S

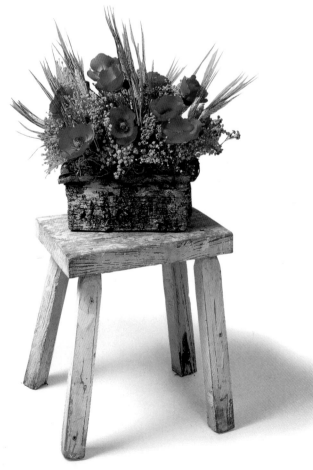

ACKNOWLEDGMENTS

I would like to thank the designers who have lent their genius to this book, particularly Cynthia Gillooly, who works at a pace that would hospitalize most and produces amazing creations. For generously providing the lovely silk flowers for the introductory section of the book, and for lending us two of their best designers, thanks to Jo-Belles in Swannanoa, North Carolina, and particularly to Louise Riddle, the store manager. For their assistance with photography props, I am grateful to Mardi Letson, Sandra Dover, and Georgia Shuford. Thanks also to Ivo Ballentine at Preservation Hall, who with good humor lent and carted props; to Craig Culbertson and Otto Hauser at Stuf Antiques for trusting us with their antiques; and to Sandy Sutker for the use of her gorgeous hair. And for her unflagging creative spirit, heartfelt thanks to Art Director Dana Irwin.

INTRODUCTION

If the mention of silk flowers conjures images of garish blooms you can spot a mile away, then you are in for a surprise. Silk flowers today are splendidly colored, unbelievably authentic looking, and come in a wide array of flower varieties. Because of the improvement in the quality of silk flowers, many floral designers and craftspeople are using silks to create durable, long-lasting, and spectacular arrangements. Although many are still reluctant to tackle silk flowers, I have yet to meet anyone who has and regrets the decision to do so.

The designs in this book have been created by a wide range of silk-flower enthusiasts, from professional floral designers to amateur craftspeople. The projects are intended to provide straightforward instructions for specific designs, as well as inspiration to design your own arrangements.

Although I have organized this book according to season, I do not want to suggest that any flower arrangement you create will need to fit neatly into one season. As you browse through this book, you will see that some arrangements could fit into several seasons. There is nothing to stop you from using, for example, a lively spring arrangement in winter.

WORKING WITH SILKS

Working with silks offers many advantages. First, when dealing with silk flowers, *you are the boss.* You are no longer constrained by the time restrictions fresh (or even dried) flowers require. You can change the look of many silk flowers by simple manipulation and need to worry much less about damaging the flower than you do with fresh or dried flowers. *Do not be afraid to touch silk flowers.*

And if you get tired of a particular arrangement, just take out the flowers and rearrange them, or try a new base or combination of flowers altogether. And once you have arranged them, they stay in place! (That is not to say they are impervious to such forces as small children and household animals.)

Even better than the freedom to handle silk flowers is the amount of time you have to create or recreate your arrangement. With minimal care (see Maintenance on page 18), silk flowers will last a long time. Chances are, your tastes will change before your silk flowers do. Long after fresh or dried flowers have wilted, lost their color, and shriveled up (all over your floor), silk flowers can be used and reused, still retaining their original hue and vitality. And although direct sunlight can eventually fade silk flowers, most can tolerate extremes of heat or cold.

Another advantage to working with silk flowers is their ability to "regenerate." If you accidently cut a stem too short, all you have to do is attach a floral pick or a wire to the end of the stem, add a little floral tape, and voila! And if you have leftover pieces (leaves, blooms, and so forth), just toss them in a bag and pull them out for a later design. There is very little waste in silk-flower design.

Many argue that silks are at their best when combined with dried or even fresh flowers, and indeed the alliance works well, as you can see by the large number of designers who have done just that in this book. The dried or fresh flowers provide a scent and "naturalize" the arrangement. When the real flowers have lost their vitality, simply replace with a different variety and you have an entirely altered arrangement.

Also, people whose allergies will not tolerate fresh flowers can fill their homes with silk flowers. And though there is no question that the scent of fresh flowers cannot be reproduced, for many the durability of silks is worth the sacrifice. As an alternative, though, you can place a decorative bottle of fragranced oils (they now come in a variety of wonderful scents) beside the arrangement. You can also use an inexpensive floral spray, but be careful not to overdo it.

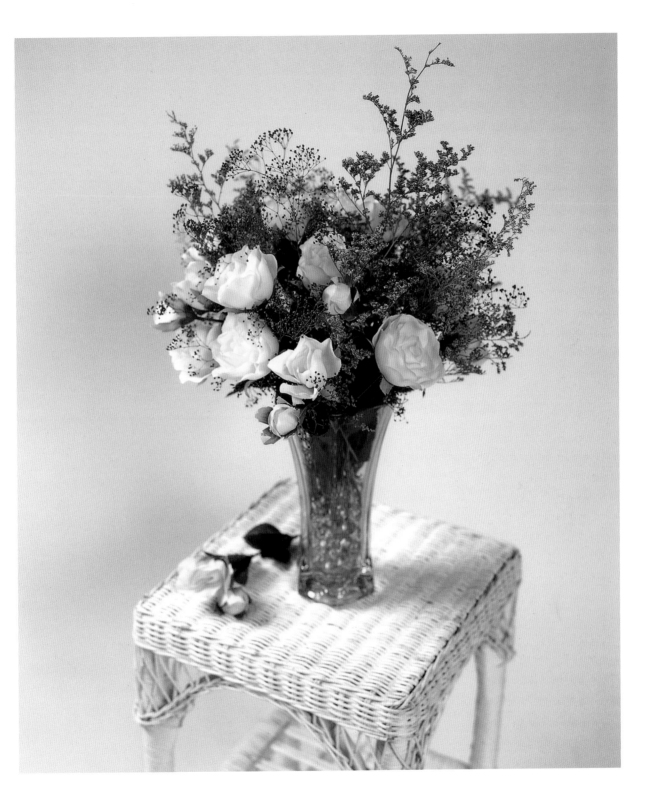

WORKING WITH SILKS

SILK FLOWER SELECTION

The variety of silk flowers in the marketplace these days is astonishing. Although most flowers are not 100 percent silk, all artificial flowers and foliage that are not plastic are collectively referred to as "silks." You will frequently find flowers that are made out of velvet or a polyester blend sold alongside "real" silk flowers for a much more reasonable price—and they are quite beautiful. Many designers swear by millinery (velvet) flowers as the height of elegance in artificial flower design (see pages 98 and 116 for examples). Determining which flowers you prefer will take some experimenting; so browse the silk-flower section of your local craft store before you get started.

You can also find silks that are intended to look dried—the colors are faded and the edges crinkled. These do not have the inherent problems of shedding and fading that

real dried flowers do and are among the most convinc-
ing artificial flowers. See pages 54 and 94 for examples
of arrangements that use these materials.

In the early 1990s, latex flowers were invented and
were quite the rage for some time. These flowers
have been sprayed with or dipped in latex, which
makes them have a whitish covering and a rubbery
feel. In spite of their popularity, you should
know they are much more fragile and can-
not tolerate direct sunlight (the color

will fade or turn brown) or extremes of temperature. However, they do have a completely different look that appeals to many floral designers.

Do not underestimate the impact of silk foliage, as it can really add to an arrangement or even stand alone (see pages 104 and 106). Make sure you look for leaves that have good color and are not too shiny—a dead giveaway.

Artificial fruit and vegetables are often used in silk arrangements. They are fun to use, and

are surprisingly realistic. Although working with these artificial materials requires a suspension of disbelief that not everyone can muster, they can be quite attractive. Give them a chance.

The range of silk flowers is endless, but do not opt for the least-expensive flowers you can find, because high-quality flowers make all the difference. *Cheap silks look fake.*

TOOLS AND MATERIALS

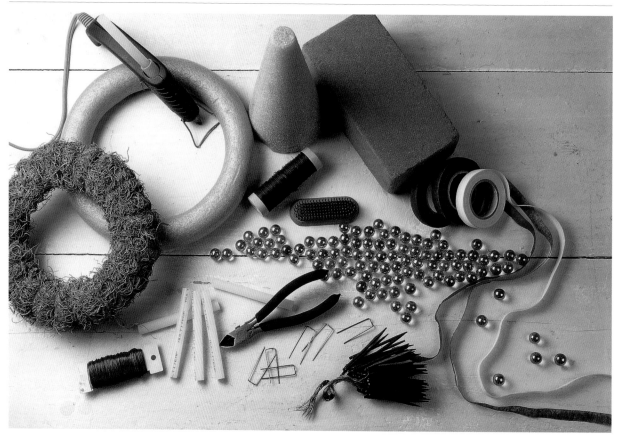

Your silk-flower experience can be much more fun and worry-free with a few inexpensive tools of the trade. Find a craft store near you and stock up *before* you get started.

BASES: If you want to make a wreath or a swag, you will often need a base for your design. If you prefer to make your own, you can do so easily, or high-quality bases are available for much less trouble at your local craft store. For wreaths, use whatever base suits your needs or your design, from a straw base to a grapevine base.

CONTAINERS: Because your silk flowers will not need water, the choices for containers are unlimited, depending on the look you want your arrangement to have. The wide variety of baskets available add a rustic look to any arrangement, and, because they are made of natural materials, add a touch of authenticity to the design as well.

FLORAL FOAM: Because most silk flowers have wire stems, using floral foam is ideal, since poking the stems into place is so easy. Generally green foam is used for fresh flowers because (when soaked in water) it serves as a water source; gray foam is normally used with silks, though you

should use green foam if you are combining silks with fresh flowers. Be careful: do not touch your eyes when working with floral foam, as it will irritate them.

SPANISH MOSS: Many of the projects in this book use moss to cover the foam base, and indeed this is a very simple and effective strategy. Spanish moss is dried and will last almost as long as your silks; and it is an easy matter to replace it when necessary.

FLORAL PICKS: These are inexpensive and help to insert flowers into the base more easily and to combine several pieces together in bunches; they are small pieces of wood, pointed on one end, with wires attached to one end. To attach one to a flower, simply place the wooden section of the pick alongside the stem and wrap the wire around both the stem and wood.

Though floral picks are commonly used to support the stems of dried or fresh flowers, they are less useful when working with silks, because the stems are usually already wired. That being said, there are some designers who insist upon picking all their materials and there will certainly be times when you will need to use floral picks to pick delicate silks, combine several stems, or lengthen silk flower stems.

FLORAL PINS: Also called *U pins* or *moss pins,* floral pins are simple U-shaped pins that are quite helpful in securing ribbon and moss. They are pressed directly into the base material.

FLORAL TAPE: Floral tape comes in a variety of colors and is used primarily in silk-flower work to cover wires so that they are unobtrusive. (Many claim the stems of silk flowers often give them

away and, for that reason, refuse to permit an exposed stem.) Floral tape also adheres firmly to floral foam and is very useful in securing foam inside containers.

FROGS: Frogs, or floral pin holders, are spiked circular plates that anchor flowers and are useful in holding flowers in place. They come in two sizes—small and large— and are available in metal or plastic. Worth the extra investment when dealing with heavy flowers.

HOT-GLUE GUN: Crafters who can't imagine life without their handy glue gun will find many uses for one when working with silks. Silk flowers are easy to glue.

MARBLES OR SMASHED GLASS: Both are popular among silk flower users, as they provide both an elegant and sturdy base.

POLYSTYRENE: This material is often used (instead of floral foam) as a base for silk flowers. It is less expensive and holds picked materials exceptionally well. It is not, however, a good idea to use polystyrene when combining silks with dried materials, as the dried stems will not stay in place as well.

WIRE: Available in a variety of weights and lengths, wire is essential in working with silks; it is especially important in lengthening and stabilizing stems. It often comes in handy when you least expect it, so always keep some wire on hand.

WIRE CUTTERS: You will most certainly need a tough pair of wire cutters to snip silk-flower stems as needed. Most silk flowers have a wire stem running through the center. You may need to cut through the outer layer of rubber, then cut the wire with wire cutters.

TECHNIQUES AND BASIC PRINCIPLES OF DESIGN

A few tips and basic principles of design will make any floral work easier and more satisfying.

■ Do not throw away silk pieces, particularly leaves, as they will almost certainly come in handy at a later date. If you have snipped off stems to shorten flowers, use the same pieces—and some floral tape—to lengthen other flowers as the need occurs.

■ Try to turn the wire spines of leaves away from the viewer.

■ If a stem is too weak or not long enough to be inserted into the floral foam, thread a wire through the base of the leaves and twist the ends of the wires together. Then cover the wire stem with floral tape. Another method is to fold a piece of wire in half, with one end longer than the other. Line the shorter wire end up beside the stem and wrap the longer end around both the stem and the shorter end of wire. Cover the length of the wire extension with floral tape.

■ It helps to turn the arrangement as you add flowers; this gives the arrangement a more balanced look that is beautiful from any angle.

■ Dip the stems of silk flowers into glue before inserting them in the base and they will hold much more snugly. This is especially helpful when working with long, top-heavy stems. If the stem is multi-wired, you can also separate the two wires to form a fork for added support; if it is single-wired, add an extra supporter with wire and floral tape.

■ In silk-flower work, it is much less important to cut floral foam to rise above the container as in fresh flower work. The wire centers of silk flowers allow them to be bent over the edge of the container.

■ *Do not be afraid to substitute.* Though I have provided specific flower names for the arrangements in this book, I encourage you to use your imagination and to experiment.

■ When you are creating silk flower arrangements, always try to imagine how the flower grows in nature. For example, always curve snapdragons slightly upward, since they always grow toward the light. Bending flowers or foliage so that they spill over the edge of the container is also an effective technique. Positioning is essential to creating realistic arrangements.

■ Establish the height and width—the outer points of the arrangement—with the longest pieces, then fill in as desired. The most fragile pieces and the filler material go in last. As a general rule, insert flowers two-thirds of the way into the floral foam and keep them about 1 ½ times as tall as the container.

■ Be sure to add depth to the design by placing flowers (particularly when you are using the same type of flower) on different planes and by turning the heads at different angles.

■ Place round flowers (for example, hydrangeas and peonies) in the center and around the lower portion of an arrangement to create a sense of balance.

■ Combine different textures, colors, and flower shapes to provide visual interest. This technique is particularly effective in larger designs.

■ The negative space, or the space between the flowers, is just as important as the placement of the flowers, because it creates curves in the outline that lead your eyes in and out of the design. Linear flowers—delphiniums, for example—will lead the eye into the arrangement and to the focal flowers.

■ Only use odd numbers of flowers/materials in wreaths, as even-numbered materials tend to give the wreath a blocky look. For example, when inserting bunches of silk baby's breath, do so in groups of five, rather than four. See pages 26 and 95 for examples.

■ Use varying stages of development (both fully bloomed flowers and buds) to give a more natural look to your silk-flower arrangements. See pages 41 and 55.

MAINTENANCE

Silk flowers require virtually no maintenance, which is one of their most appealing qualities. Nonetheless, you should take several steps to insure long-lasting designs.

First, always try to avoid putting your silk flowers in direct sunlight, because they will eventually fade. It takes some longer than others, but there is no way to get the original color back once they have faded.

Silk-flower arrangements that are to become permanent fixtures in your home will need to be dusted regularly, either manually or with a hair dryer on a low setting. If silk flowers become soiled, you can wash them in a bath of warm, soapy water. If they get squashed in storage (they may be flattened when you buy them), either work them into shape with your hands or hold them over a steaming pot of boiling water; they quickly recover their shape. Steam-ironing silks on a low setting also works wonderfully.

If you see this low level of maintenance as neglect and the guilt gets to you, commercial, ozone-safe sprays are available at your local craft store for use specifically with silks. Such sprays are said to work miracles on silk flowers by dissolving dust and freshening color.

Occasionally blooms will come off their stems, especially with smaller, more delicate, flowers. (This often indicates poor-quality flowers.) Most of the time, these can be easily reinserted on the stem, though sometimes a touch of hot glue is necessary. If this does not work, discard the stem and save the flower to use when you do not need a stem. After all, you want silk flowers to mimic real flowers— not to be *too* perfect-looking.

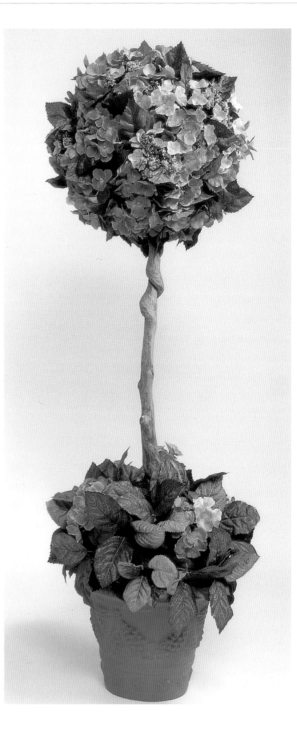

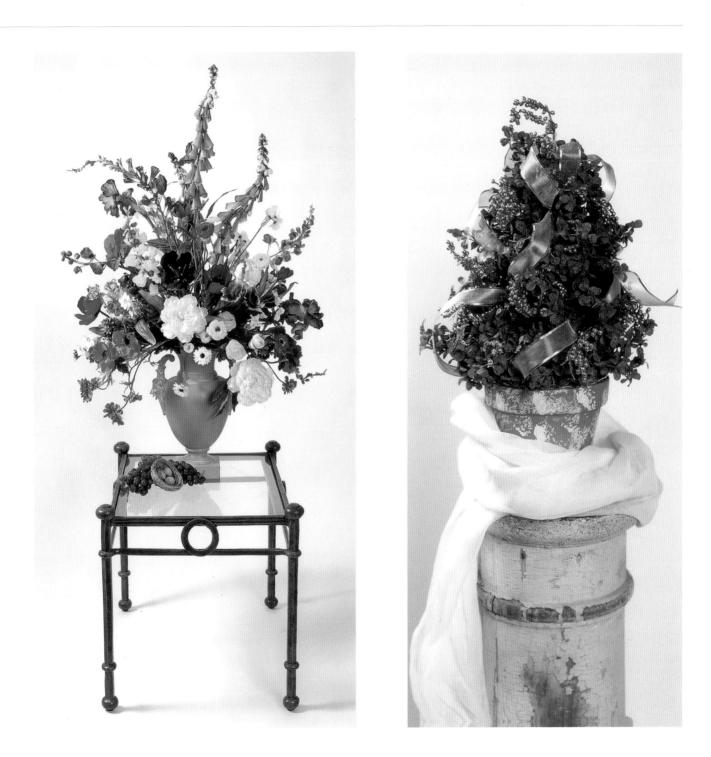

SPRING BLOOMS

> IN DAYS WHEN DAISIES DECK THE GROUND,
> AND BLACKBIRDS WHISTLE CLEAR,
> WITH HONEST JOY OUR HEARTS WILL BOUND
> TO SEE THE COMING YEAR.
>
> BURNS, *Epistle to Davie*

By winter's end, most of us

are so afflicted with cabin fever—

or a version of it—

that the first daffodil in the yard

is greeted as warmly as a long-lost friend.

With silks, you do not need to wait until the arrival

of warm weather for airy spring blooms

to brighten your mood.

BLOOMING BASKET

DESIGN: HOPE WRIGHT

A delightful array of early spring flowers features feathery yellow ranunculuses, bright narcissus blooms, and alstroemeria lilies amidst a background of cool greens.

WHAT TO DO

Use a dark brown or black basket to concentrate the focus on the flowers. Wedge a piece of floral foam into the basket and secure with floral tape. Cover the top of the foam with sheet moss and attach with hot glue.

For this arrangement, it works best to begin with the tallest flowers first and work down. Insert bells of Ireland, curly willow, and assorted pods into the back of the design to create the shape—try to achieve a pleasing asymmetry. Next insert and glue the irises, narcissus blooms, and ranunculuses. Hot-glue a head of lettuce to the center of the piece. (Larger blooms should always be kept central and low.) Last and in any order, attach yellow alstroemeria lilies, purple statice, and orange larkspur.

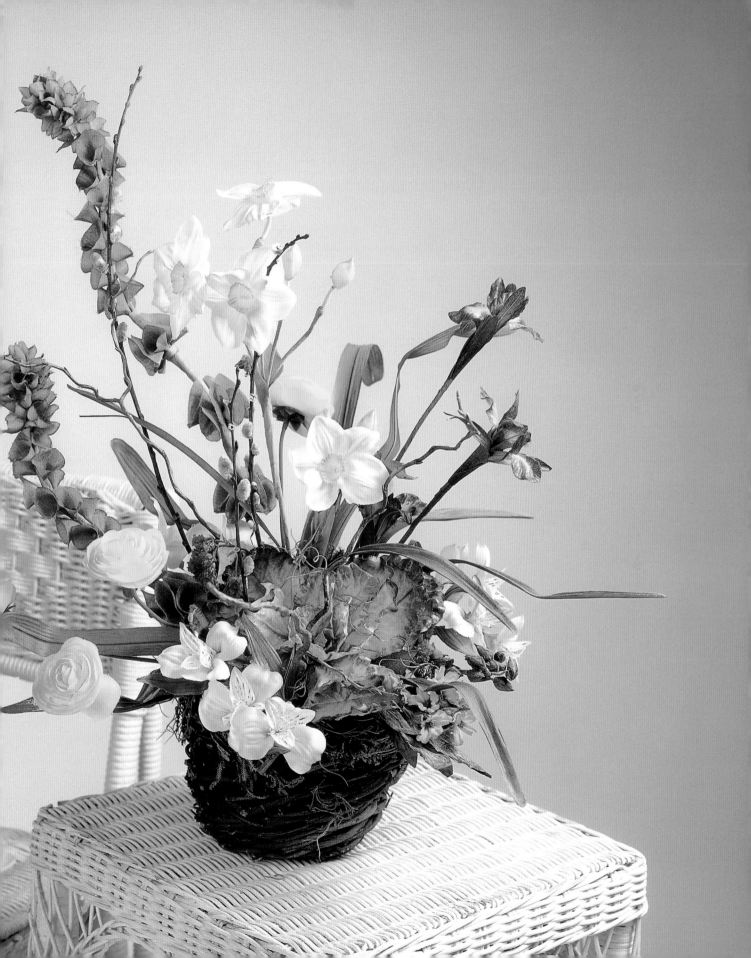

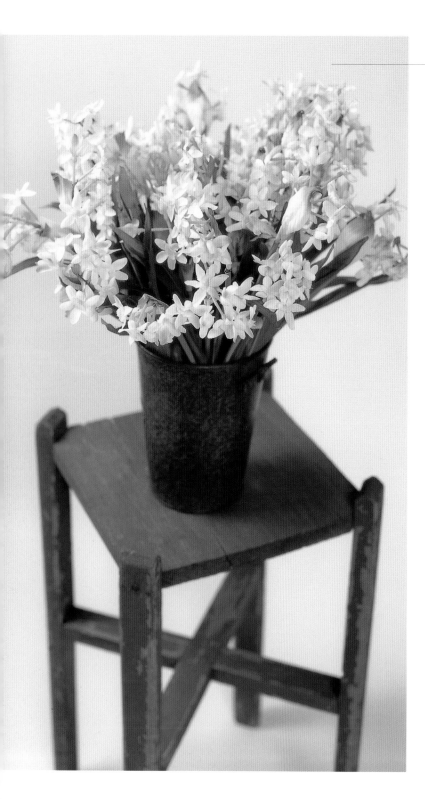

PAPER-WHITES IN A PAIL

DESIGN:
CYNTHIA GILLOOLY

This "arrangement" captures the look of freshly picked spring paper-white narcissus blossoms and requires only slightly more effort. The trick is finding just the right vessel—here, we've chosen a speckled tin container reminiscent of a farmer's milking pail.

WHAT TO DO

Often, silk flowers are sold in bunches at a reduced price. Take advantage of this for an arrangement such as this. If you have to use individually stemmed flowers, you might want to wedge a block of floral foam in the container before you begin.

Simply arrange the flowers in the container, taking care to position the flowers as they would naturally fall, with some stems drooping over the edge of the container, and other stems standing upright.

SPRING BOUNTY

DESIGN: JAMIE MCCABE

Featuring spring's oranges and yellows, this bright basket of blooms is a lesson in floral design. The taller narcissus blooms give the arrangement height, parrot tulips provide a focal point in the middle, and petunias contribute proportion and lower focal flowers.

WHAT TO DO

Wedge a piece of floral foam into a basket and cover the top with Spanish moss. Use wire cutters to cut silk-flower stems to varying heights.

You may want to use floral picks, depending on the confidence you have in your silk flowers. If in doubt, expend the extra effort. First, insert and hot-glue yellow and white narcissus plants and silk onion grass to establish the outer dimensions of the arrangement. For this piece, arrange the flowers in groups—as they would grow in nature. Orange parrot tulips are next, forming the side perimeters. Last, arrange yellow petunias in the front.

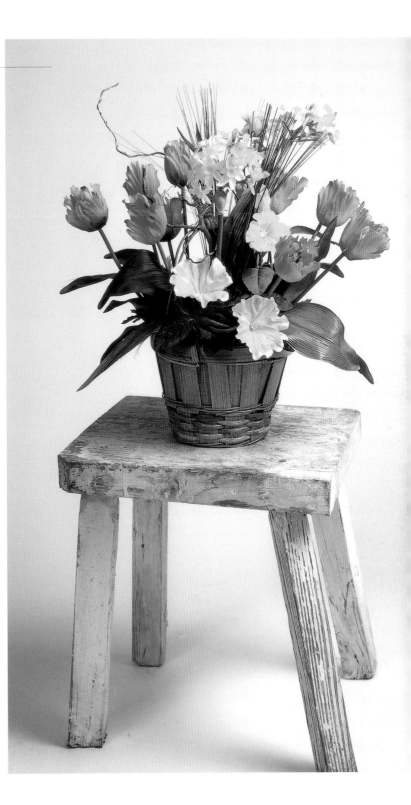

WOODSY WREATH

DESIGN: JOAN NAYLOR

There's nothing like a natural wreath to add an earthy look to any room of your house. This one features the dramatic spikes of a sweet huck wreath base and a selection of dainty silks. Although the silk miniature roses and pansies appear delicate, they will hold up much longer than their fresh or dried equivalents.

WHAT TO DO

Hot-glue sheet moss around the inside of a sweet huck wreath base. Arrange bunches of pansies, miniature roses, and angel wing begonia leaves (in groups of two or three) around the base in five spots and hot-glue into place. Affix clusters of rabbit tobacco and baby's breath to floral picks and hot-glue picked clusters randomly around the wreath.

SPRING

CLASSICAL FRENCH ROCOCO DESIGNS

DESIGN:
CATHY LYDA BARNHARDT *(left)*
AND ANNE BRIGHTMAN *(right)*

Two designers have created pieces that are reminiscent of 18th-century flower arrangements—and the results are gorgeous. The arrangements are very different, though each has the elegant curves and spaces that create the graceful formality that is characteristic of the period.

WHAT TO DO

For both arrangements: Trim floral foam at least 2 inches (5 cm) above the container and secure with floral tape. Cover the foam with Spanish moss. For a French rococo design, metal urns, metal baskets, porcelain vases, and classical-style containers are appropriate.

This type of design concentrates on the structure, texture, and color of each individual flower. There is no filler material. Consequently, take care to bend and shape each flower to its natural shape. Place some flowers deep into the arrangement—this provides shape and depth. If necessary, lengthen the flower stems (see Techniques and Basic Principles of Design on page 16).

The arrangement on the left features lilacs, delphiniums, dianthus, scabiosa, tulips, and sweet peas. The one on the right has roses, stock, anemones, poppies, snapdragons, tulips, hyacinths, iris, and carnations. Insert the longer, outline flowers to draw visual interest to the outer edges of the design, then arrange the rest of the flowers as discussed above.

SILK FLOWERS

SPRING
HANGING BASKET

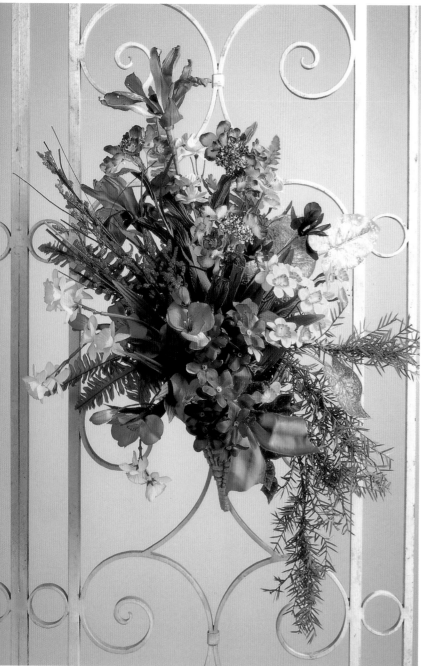

DESIGN:
FRED TYSON GAYLOR

A myriad of spring blooms in virtually every color in the rainbow abound in a hanging wicker basket. Creating a "bunched" look is an effective technique—arranging flowers as if they have been gathered together as they were picked.

WHAT TO DO

Cut floral foam or polystyrene to fit just under he rim of a wicker hanging basket; attach foam to the basket with floral wire. Cover the surface of the foam with sheet moss (dampen to handle more easily). Secure with floral pins.

For this arrangement, it will probably be more economical to buy a bunch of early spring flowers and separate them into individual blooms. Establish the dimensions of the design with spiky silk spring flowers and leaves: irises, narcissus blooms, daffodils, fern leaves, scabiosa, wild flowers, caladium leaves, and bunches of asparagus fern. Establish focal points with violets and azaleas, then fill in the design with other assorted spring blooms and foliage. Tie a bow with wire-edged ribbon and secure to the basket with wire.

SILK FLOWERS

Silk originated in China, and the Chinese have been making it for four thousand years. Legend has it that Si-Ling-Shi, a Chinese empress, was the first to discover it.

As one story goes, the empress was strolling through the palace garden and became entranced by a caterpillar's cocoon that she spied on a nearby mulberry tree. (Another story claims a cocoon actually dropped into her tea.) Regardless, she unravelled the thread of the cocoon and, determined to weave a piece of cloth from the delicate thread, she collected cocoons until she had enough thread to do so. She has henceforth been known as the "Goddess of the Silkworm."

The secret of the silkworm was kept by the Chinese for 2,500 years. For more than 1,000 of those years, only royalty was allowed to wear the precious cloth. Later, certain colors could be worn only by certain noble families. Eventually, though, silk was accessible to all of China and was sold in the marketplace.

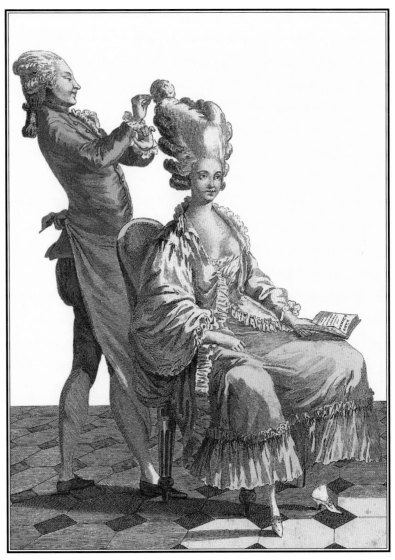

A 1778 FRENCH ETCHING SHOWS A YOUNG LADY DRESSED IN SILK ATTIRE.

Although it is still unclear how the secret of silk leaked out of China, silkworms are now cultivated all over the world. Japan is now the most important producer of silk in the world. China, Italy, France, and India are also large producers. The Chinese still use ancient methods to cultivate silk.

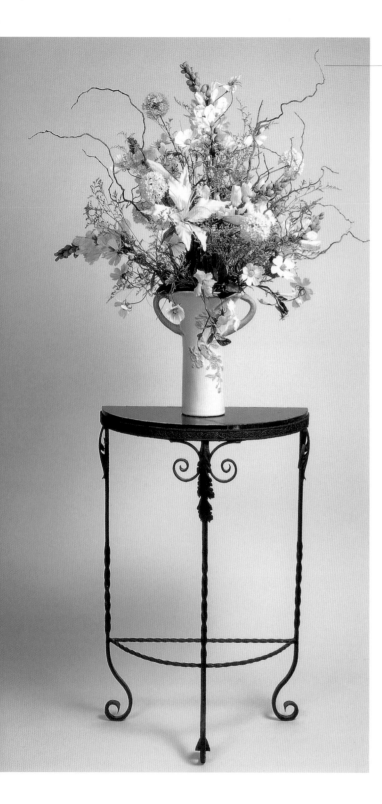

WHITE ON WHITE

DESIGN:
CYNTHIA GILLOOLY

Using only one color family is a wonderful way to create a spectacular arrangement that draws attention to textual differences among various plants. The designer has chosen a lovely clay base for this monochromatic arrangement that will go with virtually any color scheme you have.

WHAT TO DO

In this arrangement, the designer has wedged polystyrene into the bottom of the vase, as it provides a more sturdy base and is not visible. Add a touch of hot glue to the edges of the stems before you place them into the polystyrene and they will stay in place much longer.

Insert snapdragons and curly willow first to establish the framework of the design. Next, add the white lilies, which serve as the focal flowers. In any order, add alliums and cosmos; fill in any empty spots with dried freesia.

SILK FLOWERS

CATTAIL ARRANGEMENT

DESIGN:
BERNICE RICE

Take advantage of the ability to combine silks that wouldn't bloom at the same time if fresh, but which look fantastic together. This table arrangement includes the unusual combination of miniature cattail stalks and mauve thistles.

WHAT TO DO

Trim floral foam to fit inside a brass basket, with about ½ inch (1.5 cm) extending above the edge of the basket. Hot-glue foam in place. Cover with Spanish moss and secure moss with floral pins. Insert stems of three or four cattails into the center of the foam. (These cattails have lovely green grass around them—if yours do not, add some.) Place one thistle in the center just underneath the cattails, then place several additional thistles throughout the arrangement.

The white carnations should be inserted (at varying lengths) around the thistles. They serve to draw the eyes to the thistles, the inner focal points. Insert wisteria (both purple and white) around the bottom of the arrangement, near the rim of the basket. In the same plane as the wisteria, insert wandering Jew around the edges of the basket; this will pick up the mauve in the flowers. Finish by placing peach and mauve chrysanthemum pods just at the base of the central thistle.

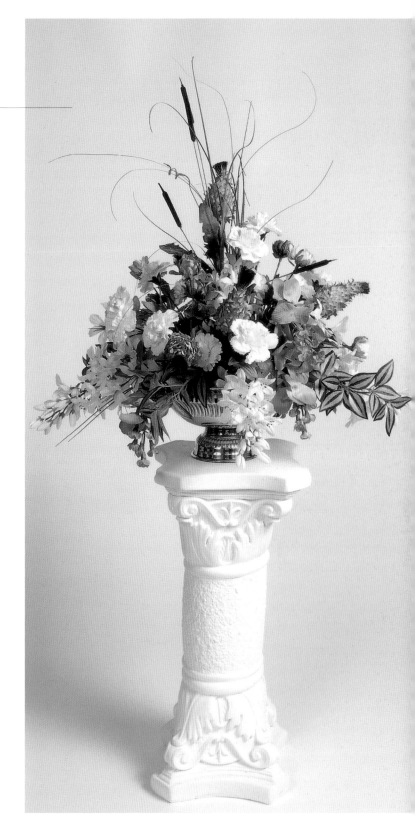

SPRING TOPIARY

DESIGN:
CYNTHIA GILLOOLY

A delightful topiary made from a variety of gorgeous silks is a stylish addition to a sunny screened-in porch or nook. The attractive base can be created from items that are probably cluttering up your basement—a terra-cotta pot and white latex paint.

WHAT TO DO

Dab a 12-inch (30.5 cm) terra-cotta pot with white latex paint, using a sponge. Allow to dry. Wedge a block of polystyrene in the pot and secure with hot glue. Depending on the weight of the topiary, you can also put gravel and plaster in the pot to stabilize the piece. If you want to do this, pour gravel in the bottom of the pot, mix the plaster according to the manufacturer's instructions, and fill the pot with the plaster, leaving about 1 inch (2.5 cm) between the plaster and the rim of the pot. *Make sure you insert your branch before the plaster sets up.* Cover the top of the pot with Spanish moss and secure with floral pins.

Find an interestingly shaped branch to use as the topiary stem. Be careful: dead wood can be brittle, so check the sturdiness of the branch before you use it. If you are using a polystyrene base, push the branch into the material and hot-glue heavily. Cover a polystyrene ball with Spanish moss—use lots of hot glue—and insert on the top of the branch. Again, use plenty of hot glue; it is essential that a topiary be very stable.

Begin the design with silk ivy. You will need two or three bunches. Cut individual stems from the bunches, attach floral picks to the stems, and insert the ivy into the ball. The ivy will establish the framework for the topiary shape. Then pick and insert the rest of the flowers in approximately this order: snapdragons, lilies, and other assorted silk blooms. Finish by inserting picked bunches of caspia. Use floral pins to attach 1 yard (.9 m) of French wired ribbon to the ball at intervals and make a bow with another generous yard (.9 m) for the base.

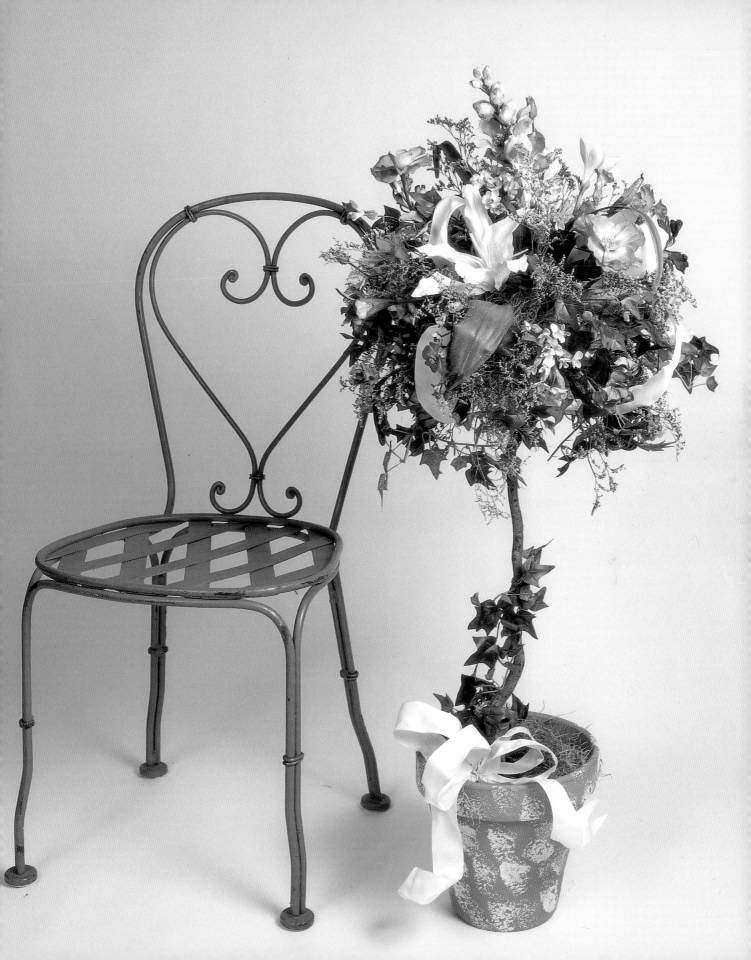

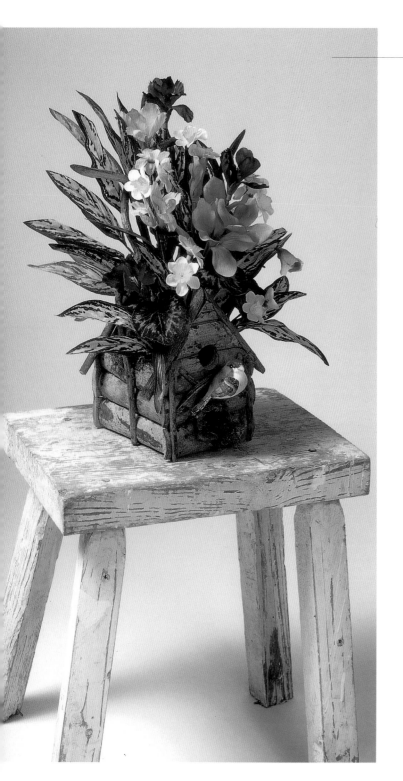

BIRDHOUSE GARDEN

DESIGN:
ELIZABETH PAYNE

In this arrangement, a cheerful garden scene bursts forth from a rustic birdhouse basket. And since the neighborhood birds will probably not be pleased with you, it might be necessary to provide a few of your own.

WHAT TO DO

Birdhouse baskets are available at many craft supply stores. This one has a handle, which is not essential. If you can't find one, cut the top out of a real birdhouse. Cut polystyrene to fit inside your birdhouse and secure with hot glue or floral tape. Cover with Spanish moss and secure with floral pins.

Arrange, hot-glue, and insert a variety of spring flowers to your liking: pink cyclamens, pink and purple irises, and narcissus blossoms. In this arrangement, because of the nature of the container, it is easiest to insert the framing materials last—in this case, peace-plant leaves. Place the leaves along the back side of the arrangement and fill in any holes as well. Glue a small bird to the perch (or any other suitable position) on the basket and a small sprig of sheet moss in the hole of the basket.

SILK FLOWERS

GARDEN MEMORY

DESIGN: ALYCE NADEAU

This charming little wreath decorates a nook in the designer's guest room. It is at home in the company of antiques, quilts, lace, and a wall of dear old books.

WHAT TO DO

Begin with a spiral birch wreath base. Hot-glue dried plumosa fern around the outside edge of the wreath base. Separate silk heather and pink baby's breath into bunches and hot-glue around the base as well.

You can buy miniature clay pots and novelty watering cans at craft supply stores. Create a small floral arrangement of plumosa fern and heather in the clay pot by hot-gluing these materials to the inside of the pot. Use brown chenille wire to attach a watering can into the center opening of the wreath. Cover chenille stems with plumosa fern and glue into place.

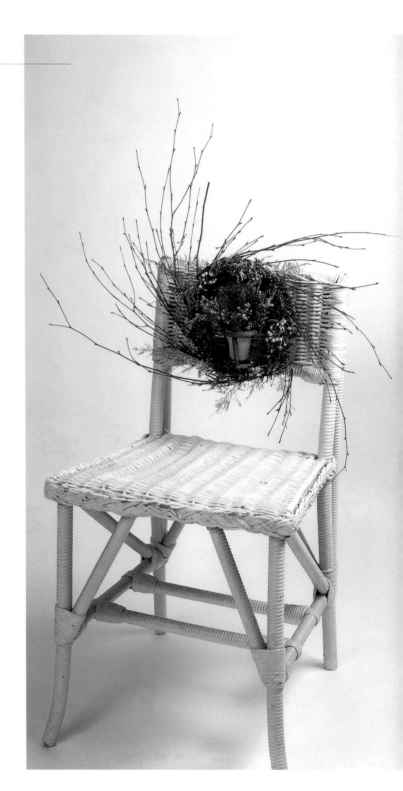

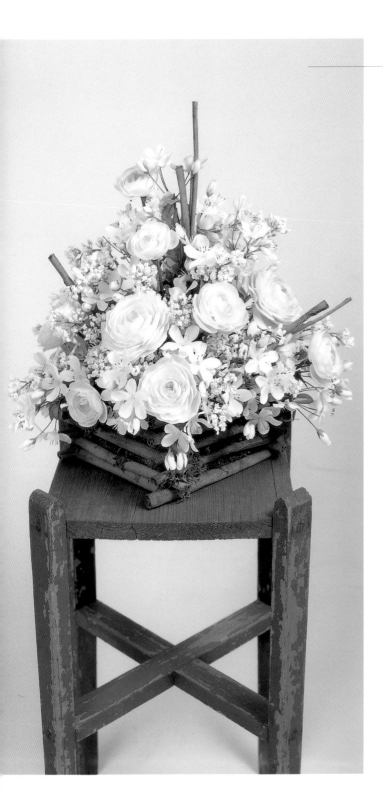

SPRING SPICE

DESIGN: LOUISE RIDDLE

In this delightful creation, the straight lines and deep brown color of cinnamon sticks contrast beautifully with the pleasing curves of exquisite pale pink ranunculuses and lush plum blossoms, creating a varied effect of form, color, and texture.

WHAT TO DO

Glue 6-inch (15 cm) cinnamon sticks along two opposite sides of a cardboard square (one that measures slightly less than 6 inches or 15 cm square), allowing the ends to extend past the cardboard. Cut two sticks to fit the two remaining sides and glue in place. Continue with rows of sticks, gluing two sticks on each opposite side. Continue this process until five sticks are stacked in each row.

Working from the inside, line the basket with sheet moss, allowing the front side of the moss to show through the sides of the basket—the spaces between the cinnamon sticks. Cut polystyrene and glue into the pocket created by the moss. Cover the top of the foam with moss and secure with floral pins.

Glue or wire some additional cinnamon sticks together into interesting groupings and wire to floral picks. Begin arranging the flowers by inserting the ranunculus at intervals throughout. Use the other flowers—white plum blossoms and white gypsophila—as fillers. Finish off by inserting the cinnamon sticks (that have been attached to floral picks) at intervals throughout the arrangement.

SILK FLOWERS

PEONY WITH LILIES

DESIGN: LOUISE RIDDLE

Silk flowers are the perfect gift for that person who just can't get anything to grow. This arrangement, inspired by the Japanese ikebana design principles, uses clear resin as "water," a technique that can be used with a variety of silk arrangements.

WHAT TO DO

Glue a "frog" or floral pin holder into a shallow bowl. Arrange a peony blossom, small lilies (with a bud), and branches as desired in the frog. Arrange small stones and marbles around the base of the arrangement, making sure the floral pin holder is not showing. Anchor stones and marbles with small dots of hot glue.

Use clear resin to create the illusion that the flowers are in water. Mix the resin according to manufacturer's instructions and gradually pour into the base of the arrangement. Make sure not to cover the tops of the stones with the resin, so as to make them appear to be dry when sticking out of the water.

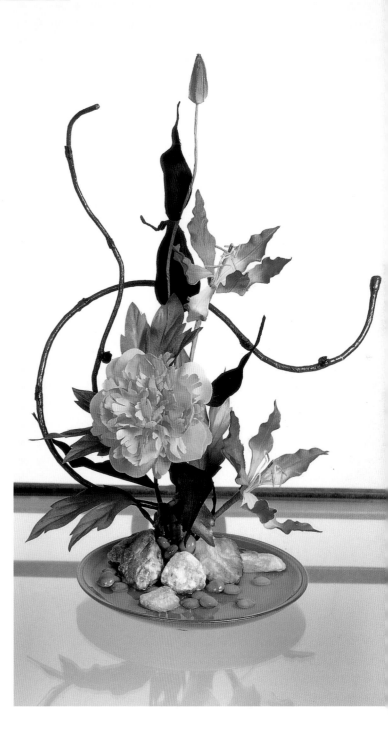

COUNTRY GARDEN WINDOW BOX

DESIGN: BERNICE RICE

Nothing sets the mood for spring like a window box filled
Randomly combining many colors and flower varieties (p
delightful impression that the blooms are growing wild—

WHAT TO DO

Here, the designer's grandson, Shannon, used his woodworking skills to make
wooden crate, but you can buy a version of it at any craft store. Place floral foam inside
the crate, using hot glue to attach the foam to the container, if necessary. (Depending
on the size of your crate, you may need to use several pieces of foam.) Cover all
exposed foam with Spanish moss and secure moss with hot glue or floral pins.

To establish the height of the arrangement, insert hyacinths, daffodils, narcissus blossoms
or any tall flowers you plan to use several inches (5 cm) into the foam in the center.
Place geraniums in the front. You might want to use several spring "bushes" (bunches of
various flowers connected at the stems) for this arrangement, because it is much less
expensive than buying individual flowers. Here, the designer has used one bush on each
side of the box.

Working from the back forward, fill in with a variety of spring flowers and foliage: tulips,
watsonia, blazing stars, pansies, narcissus blossoms, and onion grass. As you add flowers,
make sure you work with the leaves as you go, and try to include flowers in every stage
of development (notice here the designer has used many buds that look as if they are
ready to bloom). Insert yellow and red pansies in each corner. For all of the flowers, bend
the leaves so that they look as if they are growing over the edge of the crate.

DESIGNER'S TIP: If you stand back from the arrangement periodically as you work,
you will be able to get a better idea of where you need to add or take out flowers.

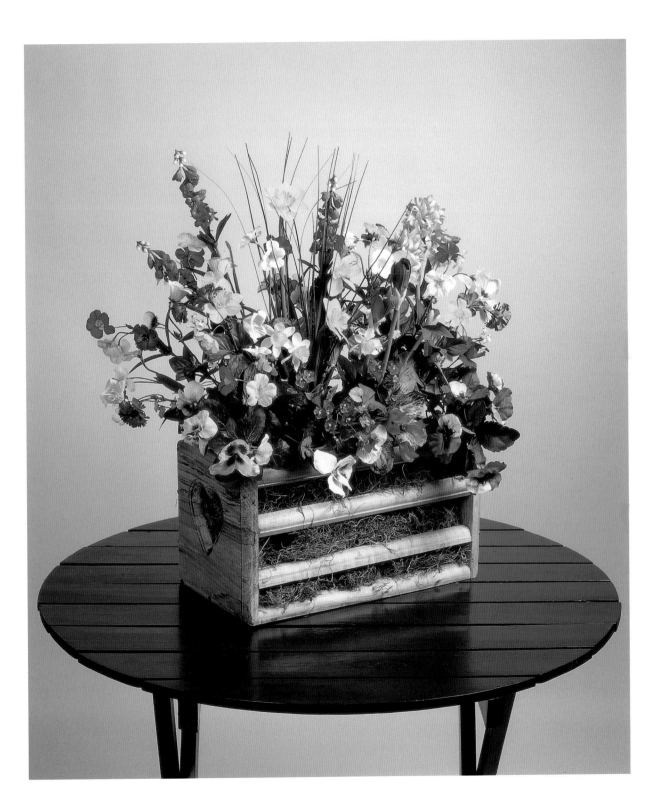

HAND-TIED GARLAND

DESIGN: FRED TYSON GAYLOR

This garland of lively spring flowers adds a touch of merriment wherever it is draped. In this case, it adorns a fireplace screen that normally goes unused in spring.

WHAT TO DO

Use heavy-weight jute or cotton cording that has been dyed green (you can buy it already dyed or dye your own) for the garland base. You will need a variety of spring flowers and foliage for this garland: baby irises, violets, crocus, daffodils, narcissus blooms, small tulips, pansies, ivy, and bunches of asparagus fern. To prepare the flowers and foliage, cut individual stems to ½-inch (1.5 cm) lengths. Extend the stems with wire (see Techniques and Basic Principles of Design, page 16) until they are 2 to 4 inches (5 to 10 cm) long. The wire extensions allow you to wrap the stems of the materials around the base.

Determine the length of your garland and cut the jute or cording about 2 feet (.6 m) longer than the finished length. Stretch the cording between two points and tie on both ends so that it is very taut. Form small groups of three to five flowers and pieces of foliage and twist the wire stems together. Working from one end of the garland to the other, twist the wire ends of the bunches around the cording. If necessary, use extra pieces of wire for reinforcement.

Continue to add bunches of flowers and foliage, overlapping the previous bunch each time and taking care to distribute the colors evenly. When the garland is the desired length, cut extra cord and tie a knot at each end. Attach bows made from narrow satin ribbon to each end of the garland.

42 S I L K F L O W E R S

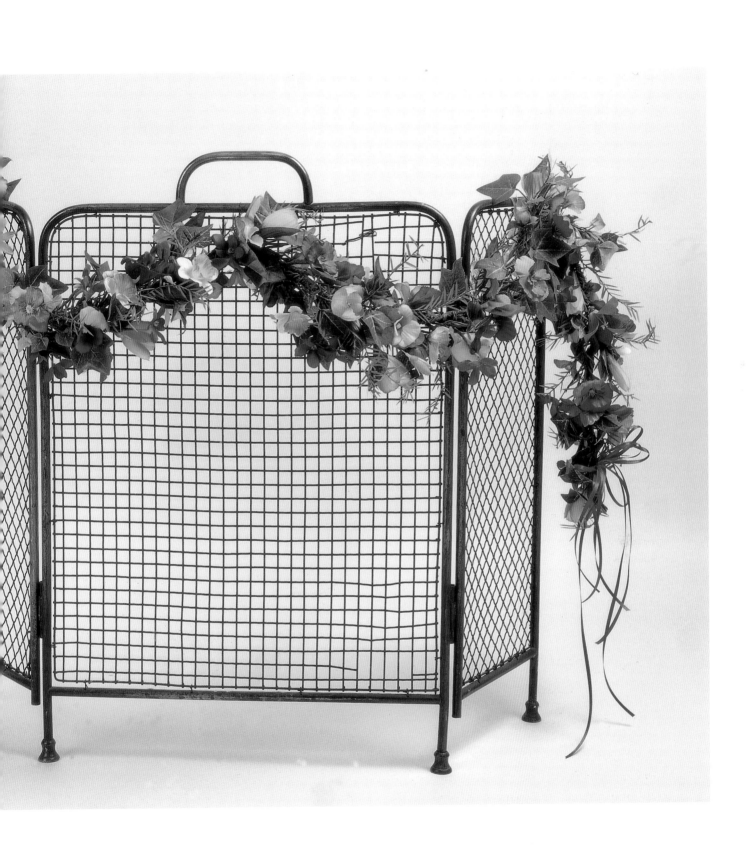

POTTED PLANTS

DESIGN: L O U I S E R I D D L E

Silk flowers lend themselves nicely to potting. With the addition of some natural materials, these gloxinias and narcissus blossoms are wonderfully authentic-looking and extremely low maintenance. Absolutely no watering required.

WHAT TO DO

Choose a clay pot in a size that will complement the silk plants you want to pot. Hot-glue a clay saucer to the base of the pot. Cut a block of polystyrene to fit the inside of the pot and hot-glue in place.

To dye the sheet moss, make a concentrated mix of green food coloring and warm water and apply the dye with a spray bottle, completely saturating the moss. When the moss has dried completely, hot-glue it to the top of the polystyrene and anchor it firmly with floral pins. Continue to glue on layers and pieces of moss along the tops and sides of the pot and saucer. The moss should appear to be growing down onto the pot. Note: dyed sheet moss is used primarily to lend a natural appearance to the potted plants, but will eventually dry out and fade.

Trim the silk stems as needed and insert into the polystyrene. Try to imitate as closely as possible how the flower grows naturally.

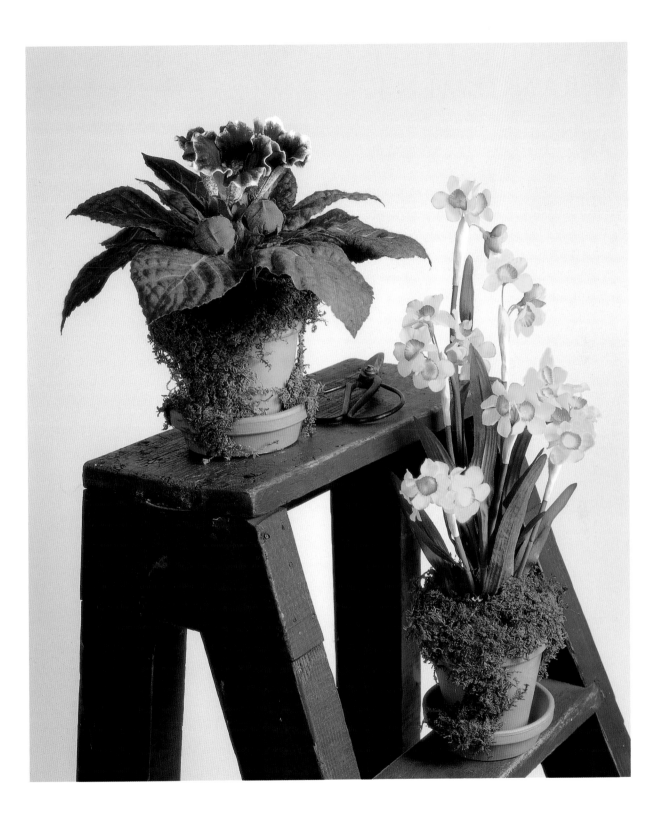

SPRING

MAYPOLE TABLE ARRANGEMENT

DESIGN:
FRED TYSON GAYLOR

The traditional May Day ritual, in which people dance around a flower-adorned pole, was held to herald the coming of spring and all its many natural wonders. This miniature maypole, a perfect tabletop party decoration, is in keeping with the tradition.

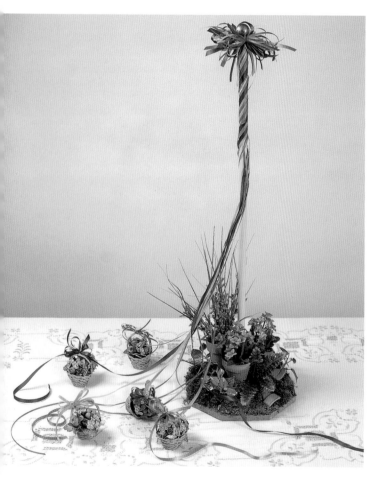

WHAT TO DO

Nail a ¾-inch (2 cm) wooden dowel to a wood block from the bottom, and reinforce with wood glue. Paint the desired color (here, yellow rod and green base). Paint a finial gold and attach to the top of the maypole with construction adhesive; allow to dry.

You will need a good bit of narrow satin ribbon in a variety of colors—about 5 yards (4.5 cm) in each color. Cut ½ yard (.5 m) from each color, divide the ½-yard (.5 m) pieces of ribbon into two equal piles, tie a bow with each group of ribbon (two bows), and attach to the maypole just under the finial. Use the rest of the ribbon as the streamers. Glue the ends of the ribbon pieces to the top of the maypole, under the finial and the bows, then wind the pieces around the pole, gluing as you go.

Hot-glue polystyrene around the base of the pole. When the polystyrene is firmly attached, hot-glue three small terra-cotta pots at the base of the pole. Cover the surface of the wooden base with sheet moss and hot-glue broken pieces of terra-cotta pot to the moss.

Hot-glue pink and purple bell flowers and pink wild flowers inside the terra-cotta pots and create "growing" plants, such as ferns and small foliage, around the pots.

Next, make the May baskets. Glue polystyrene in small wicker baskets, then glue assorted flowers, foliage, and berries (all from the same color range) in the baskets. Tie the streamers to the baskets and arrange around the bottom of the maypole.

GARDEN DROP SWAG

DESIGN: FRED TYSON GAYLOR

This collage of garden implements and silks is a delightful way to make use of broken garden tools, and a perfect decoration for a garden shed or outside door.

WHAT TO DO

Attach a hanger to the back of a wooden plank. Choose a plank large enough to anchor your materials; the size will vary according to need. Using drilled holes with screws and washers, conduit clamps, construction adhesive, or hot glue (whichever is most effective), attach larger garden items, such as a watering can, a tiki torch, a garden trellis, and flower pots. Next, attach smaller garden tools and other garden accessories (baskets and seed packets) with construction adhesive and hot glue.

Once all of the garden materials are attached securely, spray the entire surface of the drop swag with primer before completing the design. Cut and glue pieces of polystyrene inside the flower pots, baskets, and other containers as desired.

Working from the back of the design to the front, arrange silk lettuce, cabbage, asparagus fern, ivy, and zucchini (with leaves and blooms) in and around the garden equipment. Attach a spray of artificial chili peppers and mushrooms to the lower portion of the drop swag.

Cover exposed hardware, wire, and any other methods of attachment with sprigs of sheet moss.

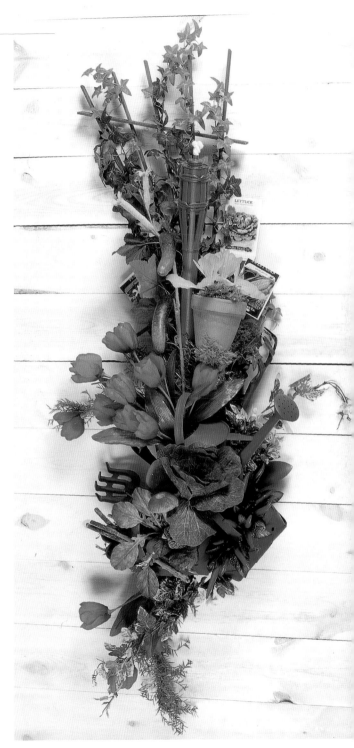

WISTERIA VINE

DESIGN:
JOAN NAYLOR

One of the best places to use your imagination to your advantage is in the woods and nothing complements silk flowers better than natural materials. This designer picked up this unusual branch on one of her regular walks in the forest around her house and created a one-of-a-kind swag.

WHAT TO DO

This arrangement is about as simple as they come. Using brown floral tape (to match the branch), tape the wisteria flowers to the branch, beginning in the middle. The key to a natural look is varying the height and placement of the blooms. When the flowers are in place, tape leaves to the branch as desired. You can substitute morning glories, ivy, or any other silk climbing flower.

SILK FLOWERS

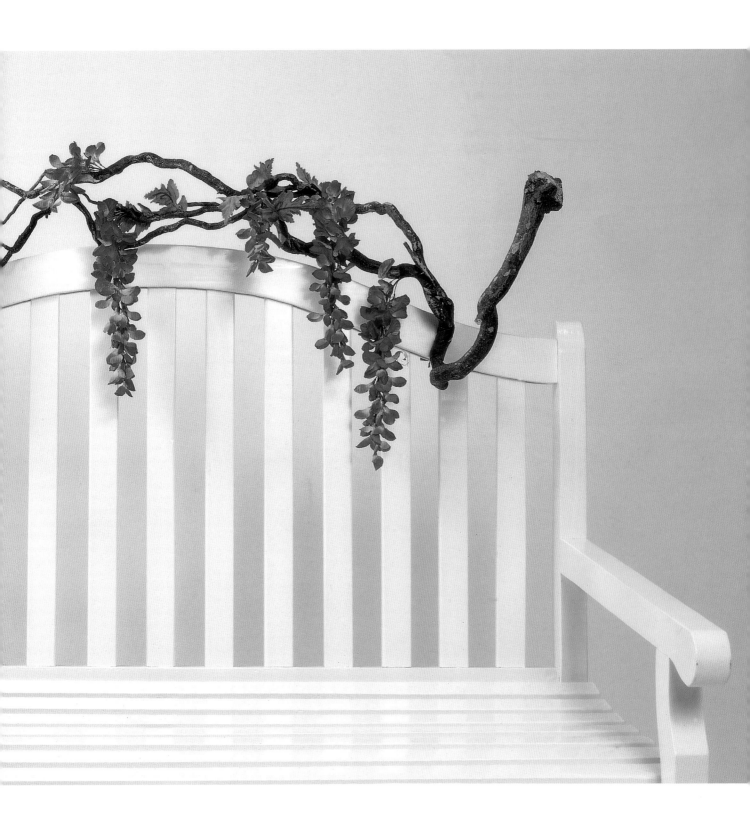

SUMMER
RADIANCE

WHERE'ER YOU WALK COOL GALES SHALL FAN THE GLADE;
TREES, WHERE YOU SIT, SHALL CROWD INTO A SHADE;
WHERE'ER YOU TREAD, THE BLUSHING FLOWERS SHALL RISE,
AND ALL THINGS FLOURISH WHERE YOU TURN YOUR EYES.

ALEXANDER POPE, *Pastorals:Summer*

Even if you do not have

the time or the space

to lovingly tend a summer flower garden,

you can still fill your home with

a profusion of colorful blooms.

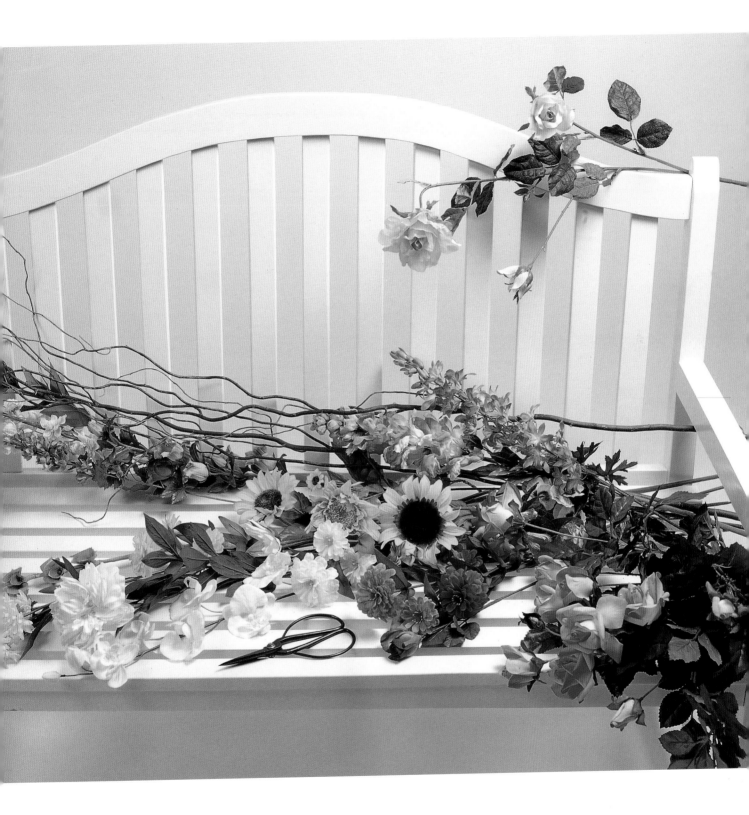

RUSTIC ROSE SWAG

DESIGN: J O A N N A Y L O R

Roses need not always be formal. This luxurious swag combines creamy ivory roses with the earthy, natural look of dried coxcomb and eucalyptus. Perfect to brighten up a window, door, or entryway.

WHAT TO DO

Manipulate the branches of an artificial pine evergreen swag base, fluffing and shaping the stems. Hot-glue the eucalyptus stems into the base first, establishing an outer border, then hot-glue silver-king artemisia to the swag. Notice the designer has concentrated the artemesia on the top half and the eucalyptus on the bottom half of the arrangement.

The roses should go in next, since it is essential that they are spaced evenly. Fill in spaces with coxcomb, light blue larkspur, and rabbit tobacco.

SILK FLOWERS

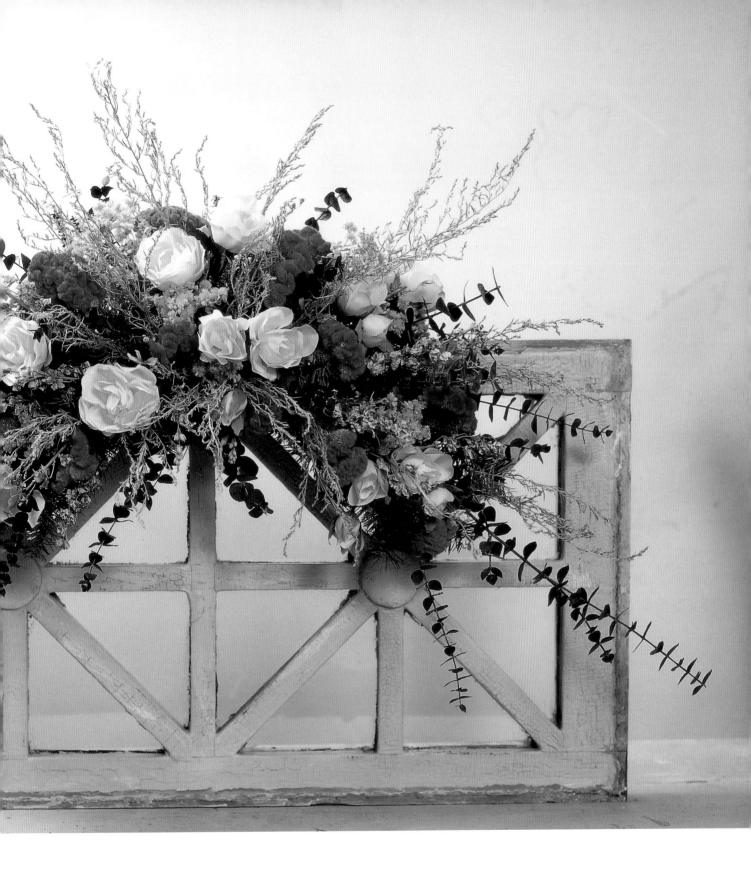

MINIATURE GARDEN SCENE

DESIGN:
MICHELLE KOEPKE WEST

This enchanting little garden scene is sure to charm people of all ages. A wide variety of miniatures is available, so use your imagination to create your own garden scene.

WHAT TO DO

Cut a piece of polystyrene to entirely fill a 12-inch (30.5 cm) terra-cotta saucer. Hot-glue polystyrene in the base and cover with sheet moss. Secure the moss with floral pins.

Begin the garden scene by making the trellis. Cut a 24-inch (61 cm) length of 2-inch (5 cm) chicken-wire ribbon (available at craft stores). Cover four stems of floral wire with green floral tape and weave the wire in and out along the edge of the ribbon. Make sure you overlap the wire ends. The wire serves to reinforce the ribbon.

Shape the ribbon into an arch and fold up a 1-inch (2.5 cm) piece on each end to serve as feet. Use floral pins to secure the feet to the polystyrene, forming a trellis. Drape silk ivy along the trellis, using floral wire to secure at several points. Bend stems of pink dried-look larkspur across the trellis and secure in the same way.

Press small pieces of polystyrene into two miniature pots and cover with moss. Push the clay pots into

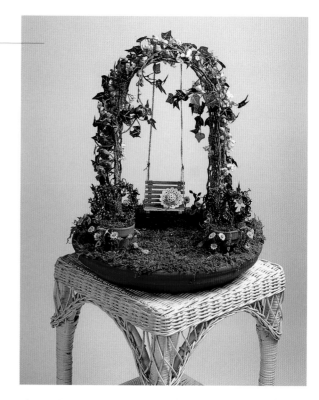

the polystyrene, lift them up again, and remove the pressed-down moss. Hot-glue pots into place in those areas. Shape artificial heather into hearts, leaving a small stem to hot-glue into the pots.

Separate the blooms in a bunch of small silk flowers and use floral wire to combine three stems, making smaller bunches. Hot-glue these bunches throughout the arrangement to create the effect of naturally growing flowers.

Make the swing seat and back by cutting strips of balsa wood with a craft knife—longer strips for the seat and shorter ones for the joining pieces. Assemble with glue. Attach strips of thin gold cord to serve as a chain. Randomly glue small stones on the moss. To finish, hot-glue two miniature birds to the ivy and a hat to the swing.

SUMMER POPPIES

DESIGN: JOAN NAYLOR

This charming arrangement is an excellent example of how including varying stages of flower development—both flowers and buds—can give an extremely realistic impression. Here, the exquisite simplicity of vibrant red poppies contrasts with the soft edges of black-bearded wheat.

WHAT TO DO

Begin with a natural bark basket or any other rustic-looking container. Cut a piece of dry floral foam to fit the basket, allowing the foam to extend about ½ inch (1.5 cm) above the basket's edge. Cover the foam with Spanish moss and hot-glue in place.

Starting at the center and working outward, insert the poppies into the foam: first the flowers, then the seed pods, and last, the leaves. Pick together random assortments of wheat, dried baby's breath, and tansies. Fill in the spaces between the poppies with the picked material. Tip from the designer: It helps to turn the arrangement as you work.

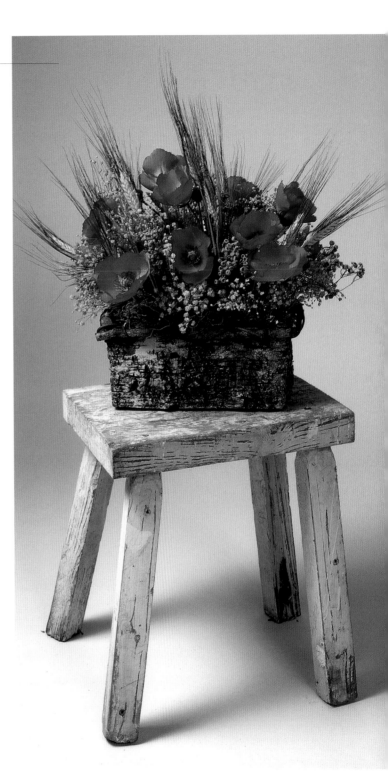

ENDURING WEDDING BOUQUET

DESIGN: J O A N N A Y L O R

This lovely wedding bouquet combines the elegance of fine silk roses with the delicacy of dried hydrangeas. And when the wedding is over, put the bouquet in a vase to create an instant table decoration—with sentimental value.

WHAT TO DO

Begin with a bunch or bush of angel wing begonia leaves. Holding this greenery in one hand, insert individually stemmed roses in a variety of sizes and

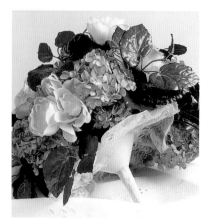

stages of development (buds and flowers) in the bunch, taking care to vary the height of the roses for visual interest. Connect all of the stems with a rubber band or floral tape. Adjust and bend the stems and leaves to create a natural appearance.

Slide the stems of the bouquet into a lace bouquet holder (available at craft stores) and snip the ends of the wire stems at different lengths to give the handle a gradually sloping look. Wrap the stems with white floral tape. After the bouquet has been assembled, place and hot-glue the hydrangeas into the spaces between the roses.

SILK FLOWERS

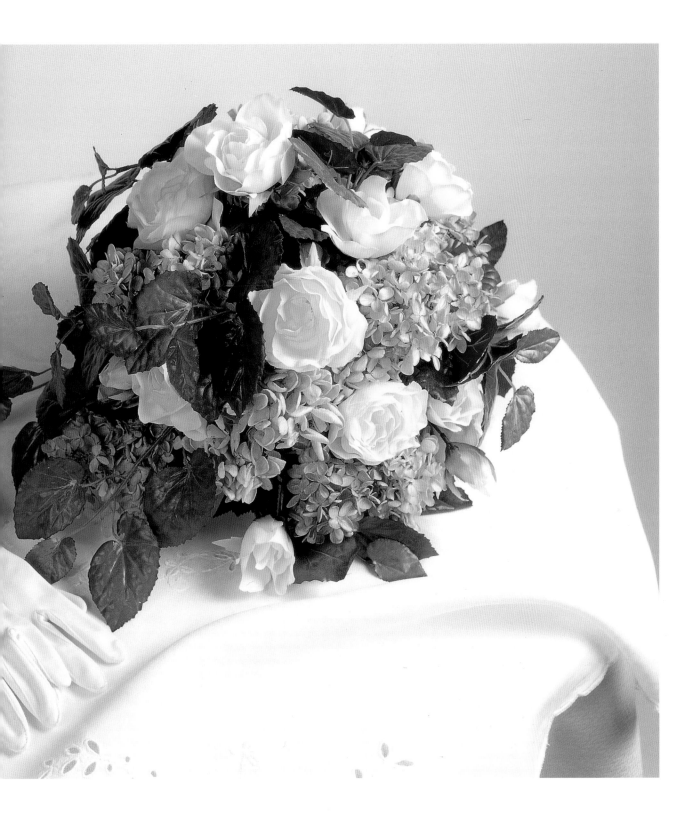

SUMMER

MARKET BASKET

DESIGN: MARDI LETSON

Why settle for a basket when you can have a basket brimming with sunny flowers and foliage? This woodsy market basket is ideal as a planter (the designer uses it for ferns), as well as for a variety of other uses—decorative, functional, or both.

WHAT TO DO

Choose a basket with a weave loose enough to wrap and insert flowers and ivy into the rim. Begin with the foliage. Here, we have used ivy and a garland of leaves that are just beginning to change color. Weave the foliage around the rim of the basket, hot-gluing at intervals; wind the leaves partially up the handle and allow pieces to spill over the edge of the basket.

Hot-glue large sunflowers around the basket. Make sure you include sunflower leaves, if possible. Next, attach pink roses and yellow wild flowers. Hot-glue sprigs of eucalyptus at the base of the handle to finish.

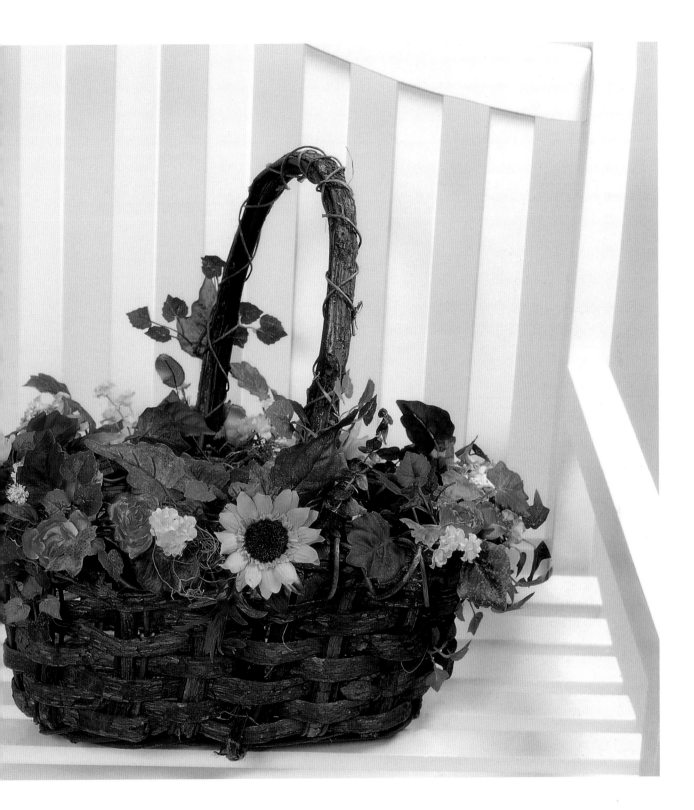

ROSE AND BERRY ARCH

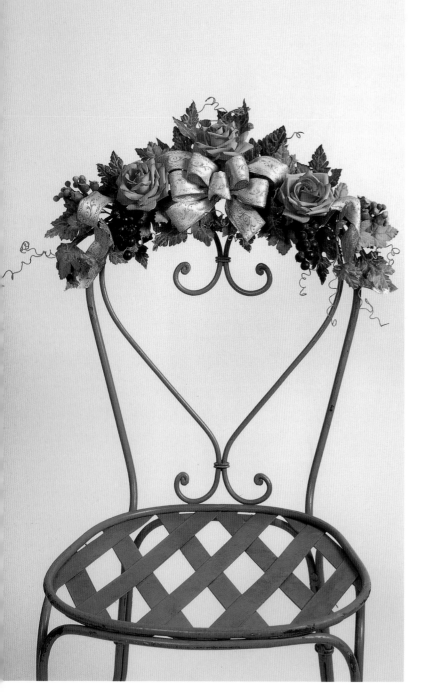

DESIGN: L O U I S E R I D D L E

Because of its subtle shades and unimposing shape, this charming little arch is delightful over a mirror or picture frame.

WHAT TO DO

Wrap several 18-inch (45.5 cm) pieces of floral wire with green floral tape. You will use the covered wire to secure the materials to the swag; the floral tape makes the wire less visible. Wire two 10-inch (25.5 cm) grape-leaf stems together to form an arch. Cut rose stems to 4 inches (10 cm) and wind into the swag so that the stems are concealed by the grape leaves. Wire to secure. Repeat with two stems of berries.

Tie a bow with 2 yards (1.8 m) of wired ribbon; use another yard (.9 m) for streamers. Wire the bow at the bottom center of the arch and weave streamers through the leaves on both sides of the arch. Using a piece of the wrapped floral wire, place a loop (for hanging the arch) on the center back of the arch.

CLASSIC ROSE VASE

DESIGN: J O A N N A Y L O R

Sometimes the simplest designs are the most intriguing. Here, long-stemmed ivory roses (both buds and open flowers) with sprigs of dried materials make for a classic blue-and-white design. This one will have your guests leaning over to sniff the freshly cut bouquet!

WHAT TO DO

The choice of a traditional glass vase enhances the classic look of the arrangement, so choose your container carefully. Hold the individually stemmed roses in your hand and arrange into a bouquet, working the stems so that they have a natural look.

Gradually work in dried caspia and blue gypsophila, still holding the arrangement in your hand. Place the bouquet in the vase and add a few marbles for stability. Arrange the flowers as desired, then add more marbles.

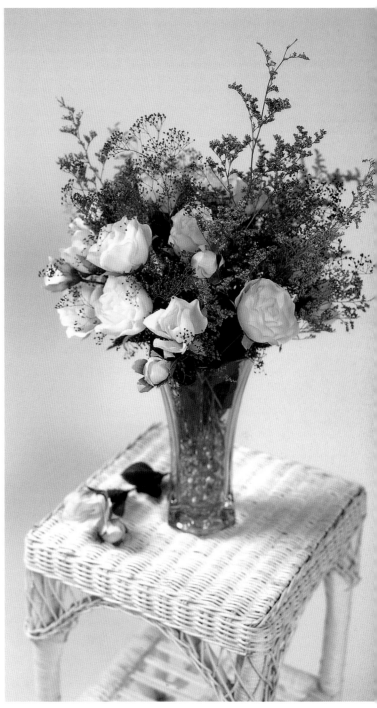

PANSY TOPIARY

DESIGN: JOANN HANDLEY

Fresh topiaries may take months or even years to perfect; silk ones are far less time consuming and, of course, require less maintenance. Colorful pansies and wired purple ribbon are spectacular accents in this one—and a lack of symmetry gives the piece a wonderfully wild, unkempt look.

WHAT TO DO

The designer has used a premade double-ball topiary form (available at craft stores), but a similar form can be made very simply. Just hot-glue two polystyrene balls together by inserting floral picks into one ball, applying hot glue to the picks, and inserting into the other ball. Insert and glue a stick, branch, or any other topiary stem to one of the balls.

Fill an 8-inch (20.5 cm) clay pot with polystyrene and secure with hot glue. Stick the topiary stem into the polystyrene and remove. Fill the hole left by the stem with hot glue and reinsert the topiary form. Since this arrangement has the potential to be top heavy, it is essential that the structure be sound. You might want to weigh down the clay pot with stones before you insert the polystyrene. Moisten sheet moss and cover the entire surface of the form with the moss, attaching it with floral pins.

You will need about six pansy bushes, three sprays of miniature daisies, and one large ivy bush for this arrangement. Cut ivy into manageable pieces and wrap the topiary; leave some stems hanging over the pot. Cut the pansies and the daisies to different lengths, then insert them into the topiary. You will probably need to attach the flowers to floral picks for easier insertion into the form.

Make two bows out of 8 yards (5.4 m) of wired ribbon—4 yards (2.7 m) for each. Attach one bow to each of the balls and secure to the form with floral pins. Allow the ribbon tails to curve and trail throughout the topiary, using floral pins to direct the ribbon. Last, hot-glue two feather birds to the form near the bows.

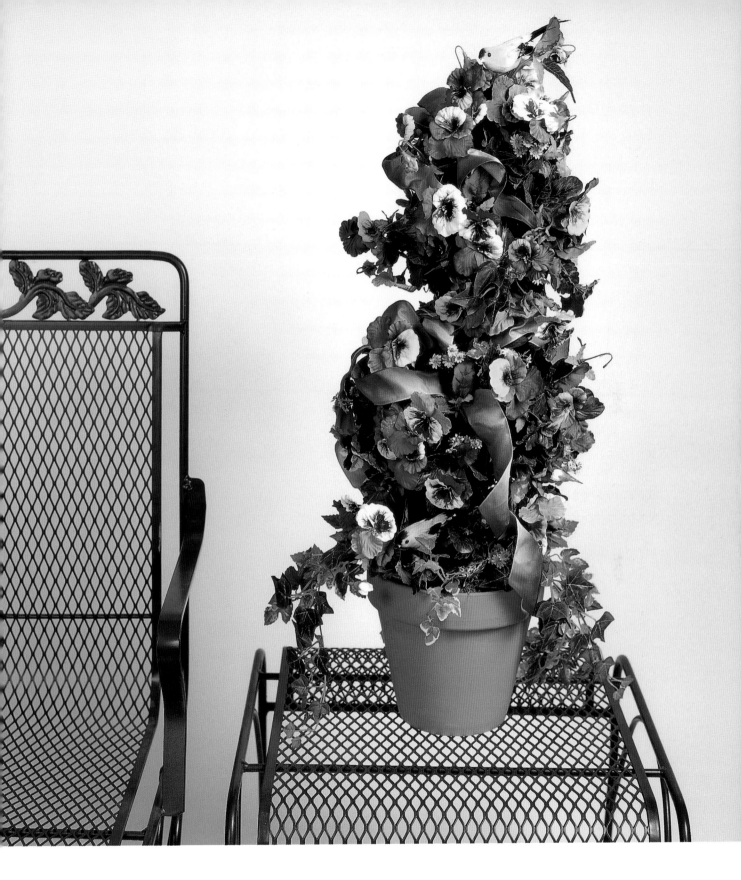

EVERLASTING ROSE GARLAND

DESIGN: JOANN HANDLEY

Abundant with delicate miniature roses, this garland adds a touch of simple elegance to any trellis, window, or fence. The simplicity of its design can be your secret.

WHAT TO DO

Garlands—already prepared and ready to drape—are available by the foot at most craft stores that supply silk flowers. This one is 5 feet (1.5 m) long and is perfect for a bed frame or a short stairway. If you cannot find a rose garland (or if you are a purist), you can certainly make your own. Wrap floral wire in green floral tape to create a base for the garland and attach 5- to 6-inch (12.5 to 15 cm) pieces of rose bush (both greenery and flowers in various stages of development) with floral wire.

Once you have the garland base, you can leave it as is—or embellish with additional silk flowers or ribbon. Here, we have made a large florist's bow out of pink wired ribbon for the center and two loop bows for the ends. Leave tails long enough on the ribbon to wind them into the entire length of the garland.

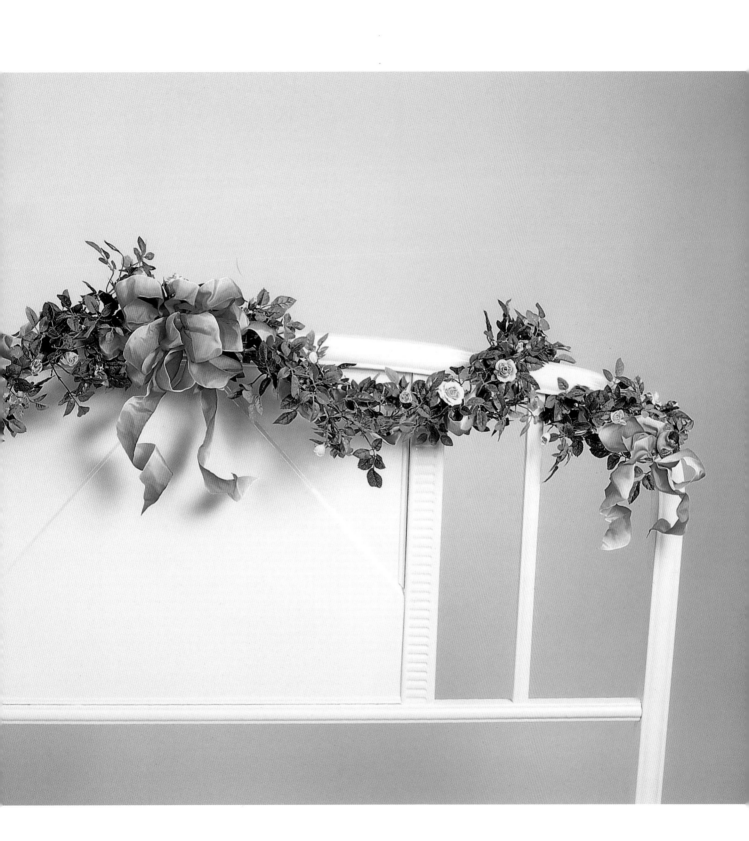

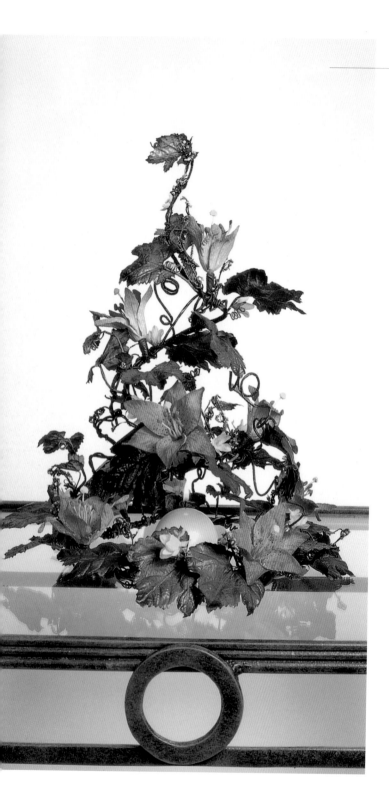

SPIRAL CENTERPIECE

DESIGN:
MICHELLE KOEPKE WEST

The airiness of this unusual design can be attributed to its hollow center, which could easily turn into a home for a candle or a light, keeping in mind the possibility of fire hazard.

WHAT TO DO

In order to create the garland, you will need grape ivy with stiff, brown, vinelike stems. Begin to twist ivy stems together to form a garland. The leafy part of one stem should lie over the bare stems of the next. Cover 22-gauge wire with brown floral tape and twist wire throughout the stems and leaves so that it blends with the vine; the wire serves as support for the design. Continue to overlap ivy stems and wire until the garland is the desired length.

Shape the garland into a spiral, beginning at the top. Form a small circle at the top, then continue to form circles—each one larger than the one before. Use 20-gauge wire wrapped in brown floral tape to form braces between the circles to keep the spiral from collapsing. Gently bend and twist the wire before attaching it to the spiral—so that it will look as natural as possible.

Space the lilies evenly throughout the spiral and attach with covered wire or hot glue. Finish off by hot-gluing small yellow filler flowers to the spiral.

SUNFLOWER WALL BOUQUET

DESIGN:
LOUISE RIDDLE

An informal display of long-stemmed sunflowers is complemented by colorful sunflower-print ribbon. Ideal as an adornment for a country barn door, or any other rustic setting.

WHAT TO DO

Arrange sunflowers into a bouquet and wire stems together for 3 or 4 inches (7.5 or 10 cm). Just below the bottom blooms, wrap the wired area with several layers of green floral tape to conceal the wire and to keep the stems securely in place. Cut any leaves off below this area.

Bend stems out to the sides and cut to desired lengths. Make a large bow from the ribbon (it will take about 5 yards or 4.5 m). Wire the bow on to conceal the wrapped section and secure in several places with hot glue.

Use floral wire wrapped in floral tape to shape a hanger on the back of the bouquet.

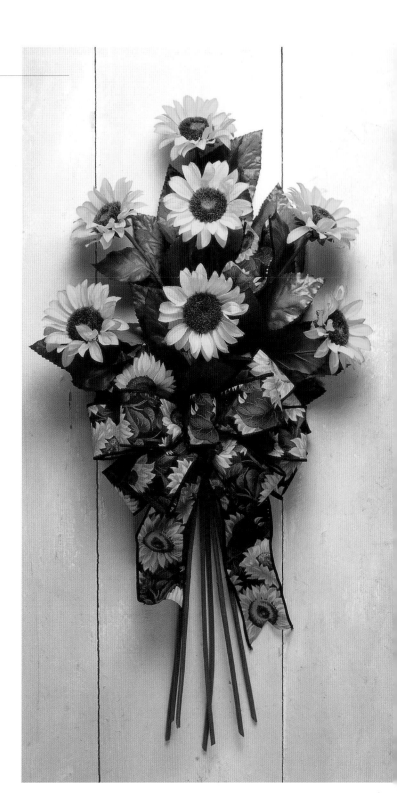

HARVEST WHEELBARROW

DESIGN: ANNE BRIGHTMAN

Rescue the old wheelbarrow in your garage that has been out of use by transforming it into a piece of floral art. Sure, you will need enough space to do justice to this profusion of flowers and greenery, but, oh, what an impression it makes!

WHAT TO DO

You will need enough floral foam to fit inside half of your wheelbarrow base and extend 2 inches (5 cm) above the edge. Cut and trim the foam and secure with floral tape. Cover the entire surface of the foam with Spanish moss.

This arrangement's appeal is due largely to the striking effect of flowers and foliage in the same color family with varying textures. Begin by inserting the tallest flowers—hydrangeas, delphinium, snapdragons, bells of Ireland, onion grass—to establish the height of the arrangement. Then insert the focal flowers and vegetables: cabbages (several varieties), dusty miller bush, liatris, roses, scabiosa, alstroemeria.

Take care to allow ivy, berries, and any other trailing foliage to spill over the edge of the cart, to convey a "brimming over" look. Insert the flowers at different angles and bend and shape them individually, to provide a natural look.

Prepare the terra-cotta pots for the cart by filling them with polystyrene, covering the tops with moss, and attaching fruits and vegetables—artichokes, leeks, cabbages, apples, grapes—with hot glue. You might need to put packing material between the terra-cotta pots and the floral foam for stability.

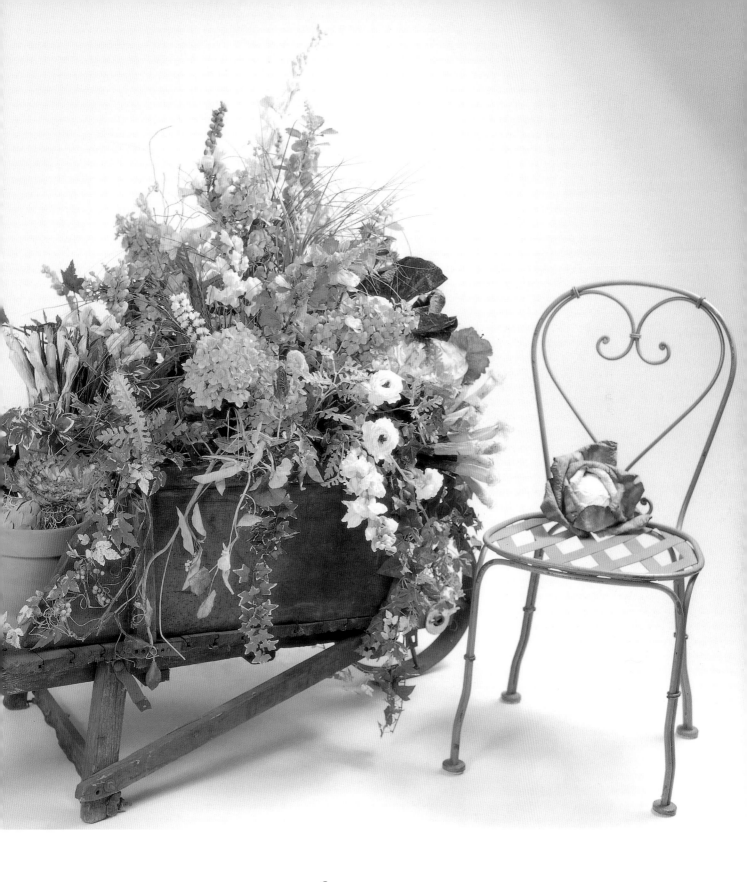

DUTCH MASTERS
ARRANGEMENT

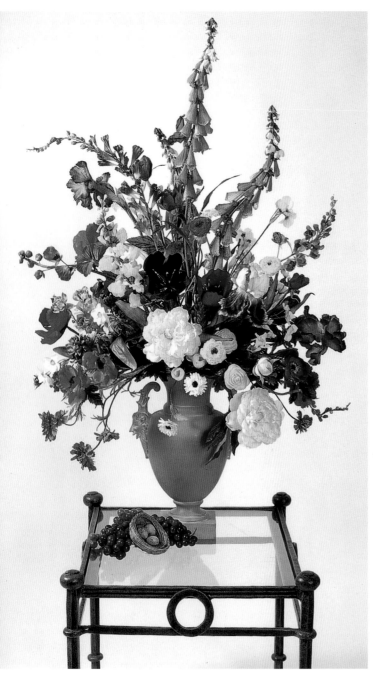

DESIGN: C A T H Y L Y D A
B A R N H A R D T

*Inspired by flower painting from the Netherlands,
this arrangement was created by a designer who is
interested in period design of the late seventeenth
and early eighteenth century. See the sidebar on
how to create a design in keeping with the tradi-
tions of the Dutch Masters (page 71).*

WHAT TO DO

Trim floral foam leaving 2 inches (5 cm) above
the container's edge and secure in place with flo-
ral tape. Cover the foam with green sheet moss,
using floral pins.

For this design, you might need to lengthen the
stems of many of the flowers with wire and stem
tape (see Techniques and Basic Principles of
Design on page 16). First, place flowers to estab-
lish the height, width, and shape of the design:
delphiniums, hyacinths, irises, and poppies. Then
insert the flowers that will serve as the focal
points: anemones, ranunculuses, peonies, and
roses. Then fill in with the rest of the flowers: nar-
cissus blooms and strawflowers.

For this design, it is important to use a wide vari-
ety of materials. Imagine how the flowers would
look if they had been freshly cut.

S I L K F L O W E R S

HOW TO CREATE A PERIOD DESIGN IN THE TRADITION OF THE DUTCH MASTERS

CATHY LYDA BARNHARDT

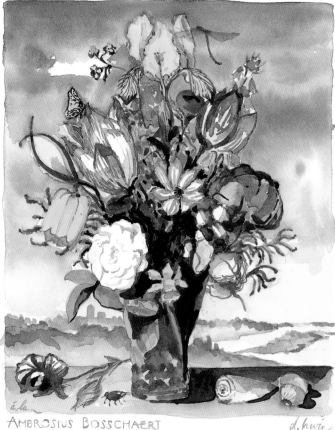

AMBROSIUS BOSSCHAERT

d. hwin

The Dutch flower painters created completely imagined flower arrangements; they never actually existed, but were quite beautifully designed nonetheless. With some guidelines, silk-flower designers (who, like the Dutch Masters, have absolute freedom in floral design) can easily recreate these arrangements.

Color: *warm yellows, oranges, reds, blues, pinks, and whites, all softened by the flower's own green foliage. Usually, there are strong contrasts, and the pieces often show detail, variegation, and texture.*

Container: *terra-cotta urns, delftware, bottle and glass shapes, flower or posy holders.*

Flower content: *Flowers grown or popular during the period are tulips, irises, narcissus, hyacinths, anemones, ranunculuses, poppies, roses, peonies, and delphinium.*

Setting: *windowsills, side tables, and tops of cabinets*

Style: *Designs from this period are often massive, but not static; the outline flows and has rhythm. The shape is usually oval with open spaces at the outline to create curves and to reveal the structure of the individual flowers. Although there is a great profusion of material, it should not be crowded; the flowers should not lean on one another.*

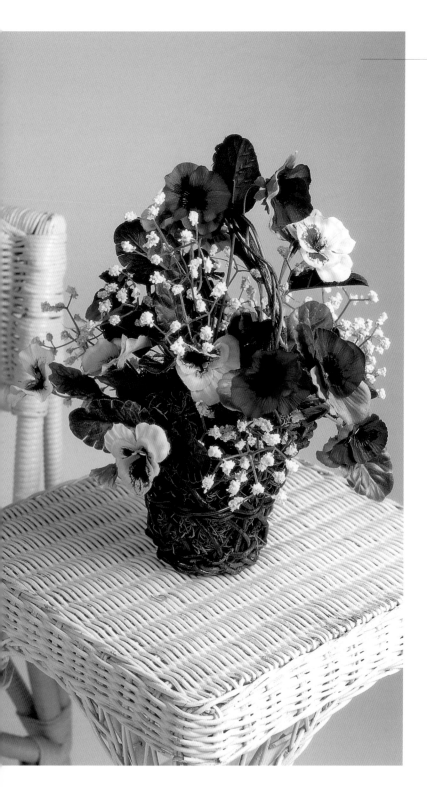

DAINTY PANSY BASKET

DESIGN: JAMIE MCCABE

This traditional pansy basket is a great silk-flower project for kids, because it is simple in composition, extremely attractive, and the perfect size for a child's bedside table or dresser top.

WHAT TO DO

Cut a block of floral foam to fit inside a small grapevine basket. Before you glue the foam into the basket, completely cover it with sheet moss, using hot glue or floral pins to secure. Then glue the foam inside the basket, taking care that no floral foam is showing.

Use wire cutters to cut the pansy stems to varying heights. Insert the pansies into the foam, with the tallest blooms reaching just over the handle of the basket and the shortest ones spilling over the rim. Finish the piece by adding silk baby's breath to the void areas.

HATBOX ARRANGEMENT

DESIGN:
CYNTHIA GILLOOLY

Do not limit yourself when it comes to choosing a container for your silk flowers. An old sugar bowl, cookie jar, or even a teapot can have endless possibilities—and it does not have to be waterproof. Here, a designer has taken a long-forgotten hatbox and created a stunning arrangement.

WHAT TO DO

Fill the base of the hatbox with floral foam to just under the rim. Insert a floral pick into the back of the foam at an angle and hot-glue the lid to the pick. Check the angle to make sure it works before you glue.

Begin the arrangement by inserting curly willow and delphiniums to establish the dimensions of the piece. There should be a fringe of curly willow extending from the top and all around. Then create the shape by adding the pansies and pink gerbera. Fill in spaces with silk English ivy and leaves. To finish, insert artificial raspberries and assorted pods as desired.

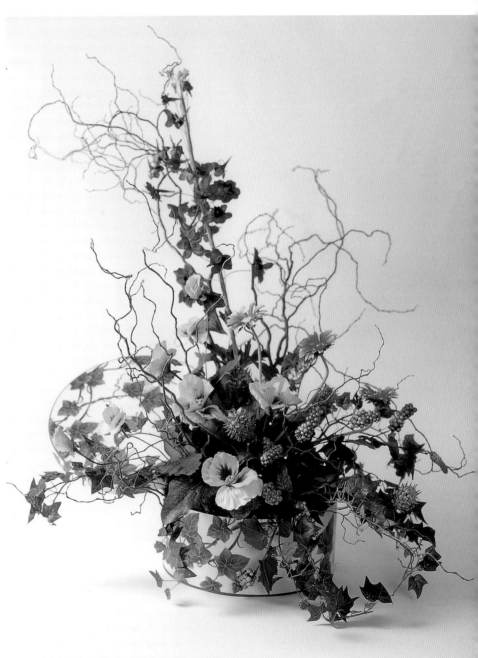

SUNSHINE BASKET

DESIGN: JOANN HANDLEY

A radiant arrangement of sunflowers, black-eyed Susans, and peacock daisies is sure to brighten any room of your house. The dark-colored basket picks up the centers of the flowers to create a gorgeous table decoration.

WHAT TO DO

Tightly pack a large, square basket with floral foam. Cover the foam with Spanish moss and secure the moss with floral pins.

Use an assortment of yellow and orange flowers: large yellow and orange sunflowers, black-eyed Susans, small sunflowers, peacock daisies, and heather. First, insert the large flowers at angles at even intervals throughout the basket. Then, place smaller sunflowers and black-eyed Susans in between the larger flowers. Fill in with peacock daisies and heather.

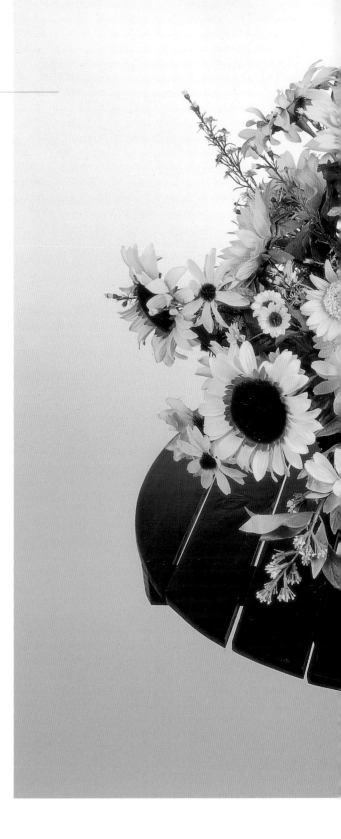

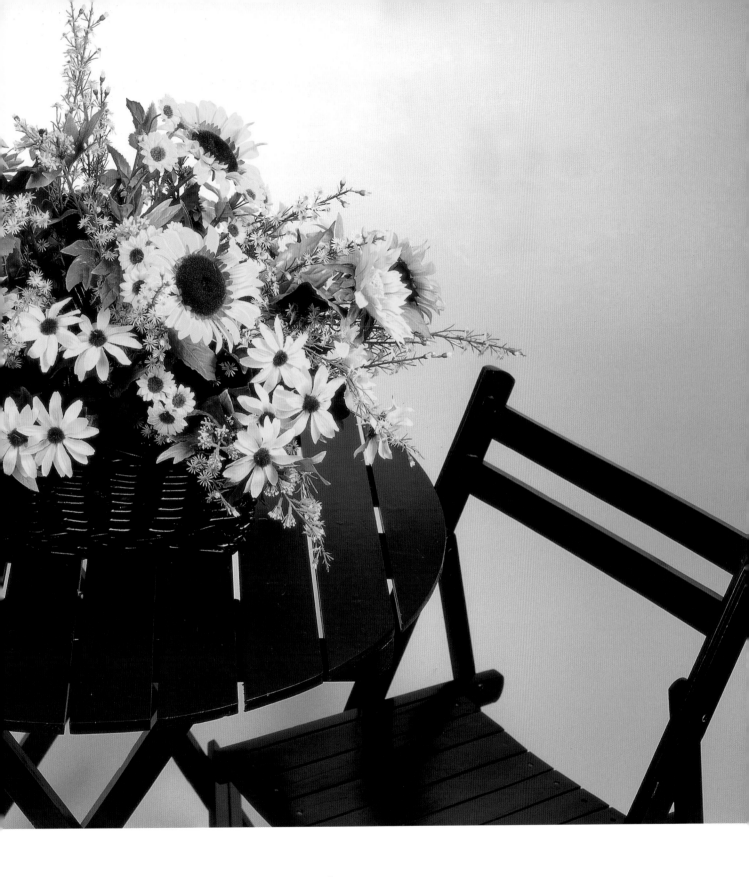

LONG-STEMMED SNAPS

DESIGN: CYNTHIA GILLOOLY

Here, a tall vase of snapdragons—all in the same color range—makes for a classic arrangement.

WHAT TO DO

Although many silk flowers are stable enough alone in a simple vase with marbles, heavy-stemmed silk flowers will probably require floral foam. (Some designers even use plaster in the bottom of the container.) Here, Spanish moss has been hot-glued to a small block of foam; the foam is then inserted into the vase. Once the base is secure, insert the flowers into the foam, bending the stems to imitate how they would naturally fall.

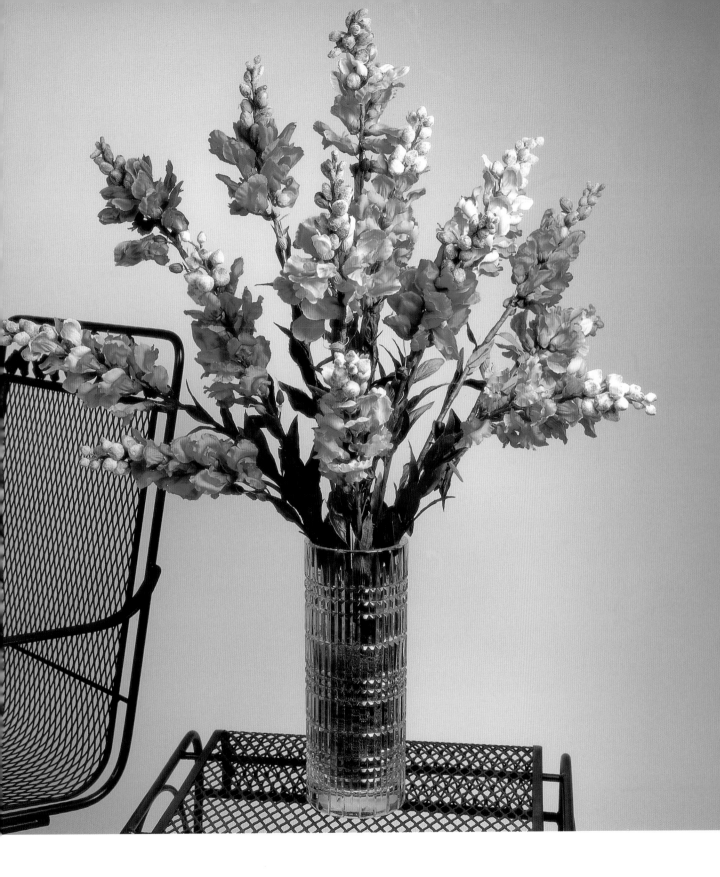

FALL
HARVEST

With the first brisk fall breeze

come images of pumpkins, warm sweaters,

and brightly-colored leaves.

Take advantage of silk flowers in warm

autumn colors—they make for delightful

silk floral arrangements.

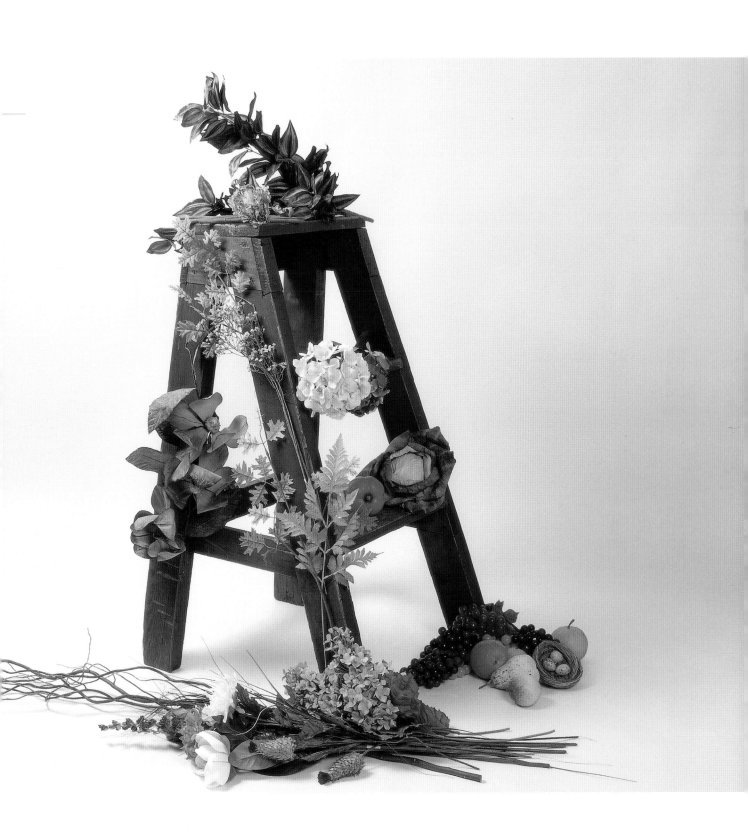

BASKET OF GRAPES

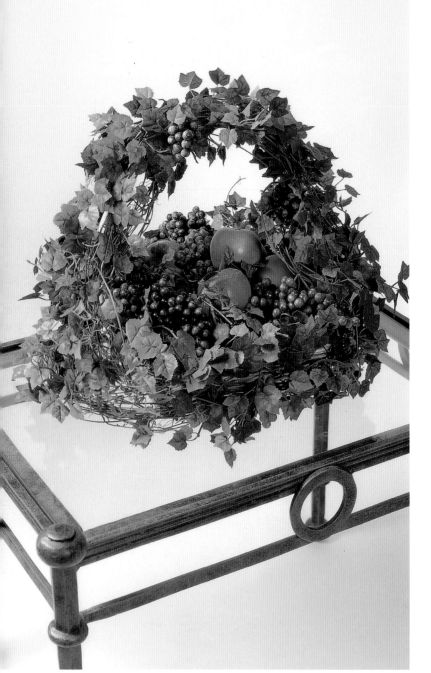

DESIGN:
J O A N N H A N D L E Y

Grapevine, silk ivy, and luscious fruit (why mention it's artificial?) come together to make this handsome fall basket. The fruit has been treated with wood glaze and baby powder to create a just-harvested look.

WHAT TO DO

Begin with a square basket; a basket made of natural materials works best. Wrap the basket with three 48-inch (122 cm) pieces of grapevine, using floral wire to affix the vine. Once the vine is secured to the basket, weave grape ivy through the grapevine, again using floral wire as necessary to secure. It will probably take, depending on your basket, about four standard-sized grape ivy lengths to cover the entire surface of the basket. Do not forget to fill the inside of the basket.

You will need about 12 small grape clusters and five medium apples to fill the basket. Before placing fruit in the basket, spray it with wood glaze. Put a small amount of baby powder in a plastic bag, add the fruit (one piece at a time), and shake. Remove the fruit, shake off any excess powder, and allow to dry thoroughly. When the fruit is ready, position it in the basket and hot-glue into place. Wire several bunches of grapes to the handle of the basket as a finishing touch.

WILD FLOWER BOUQUET

DESIGN:
MARDI LETSON

Capture the look of just-gathered wild flowers with this assortment of radiant blooms. The warm hues of these flowers are reminiscent of a meadow of bright blooms in Indian summer.

WHAT TO DO

This design features a lovely bark basket with leather trimming, but any earthy container or basket will work. Wedge a piece of floral foam in the basket. In this arrangement, the foam should not be visible above the edge of the basket. Depending on your container, you might want to soften the edge of the basket with Spanish moss.

The key to this arrangement is selecting the flowers carefully. Make sure the colors you choose mesh visually, but do not try to "match" them. First, create the outline of the design by inserting the stems that are to go in the center and back, then fill in with the remainder of the wild flowers. Here, we've chosen strawflowers, mountain forget-me-nots, wild larkspur, mountain kalanchoe, wild bellflower, and a variety of other silk wild flowers.

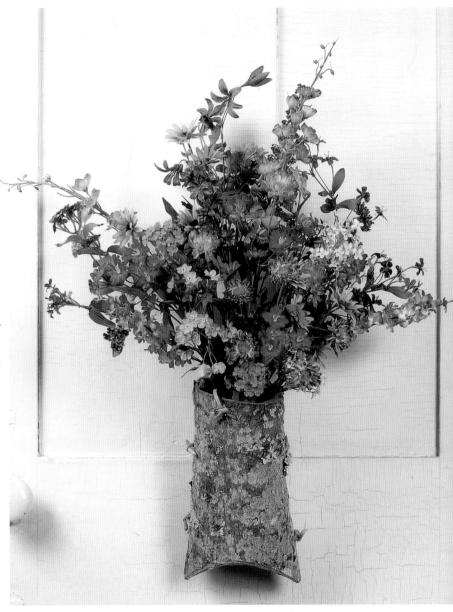

AUTUMN

VEGETABLE HARVEST BASKET

DESIGN: MARDI LETSON

Utilizing the wide variety of artificial vegetables that are now available, this arrangement highlights the beauty of ripe, freshly picked produce. The silk ivy serves to connect the more self-contained individual vegetables.

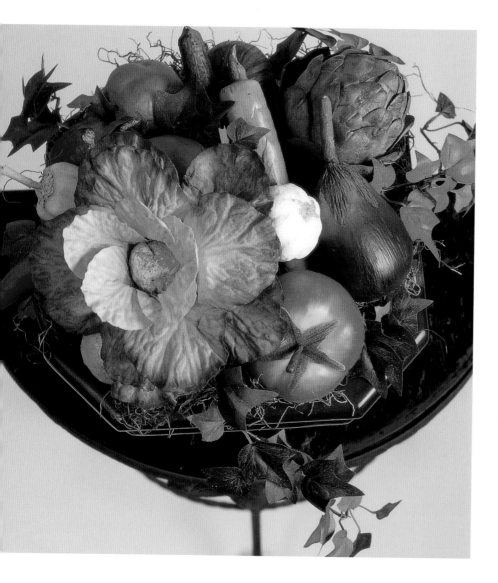

WHAT TO DO

First, choose your container; the deep brown hues of this wooden bowl make for a wonderful vegetable bowl. Fill the inside of the bowl with floral foam and secure with floral tape.

Begin the design with the larger vegetables, in this case the cabbage and the artichoke. Then fill in spaces with the rest of the vegetables, taking care to use vegetables of contrasting textures, colors, and shapes for visual interest.

Finish by weaving ivy between the vegetables, allowing several stems to spill over the edge of the bowl. This arrangement also works well with artificial fruit. Using hot glue or floral pins, cover any exposed foam surfaces with Spanish moss. (Make sure the floral tape is completely covered.)

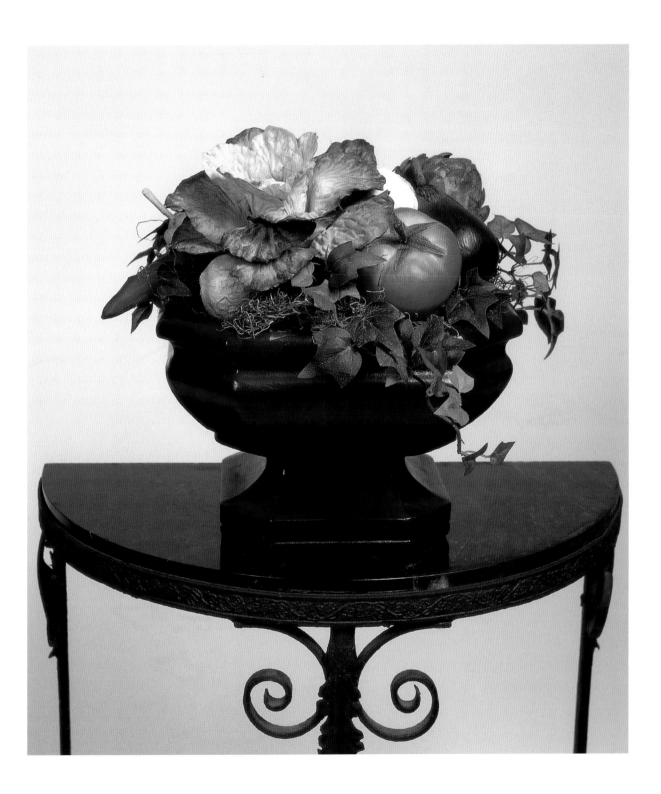

AUTUMN

SILK FLOWERS AND WEDDINGS

*S*ilk flowers have long been favorites for weddings. Although a silk-flower arrangement will probably be slightly more expensive than a fresh one, it can be used for the bridal shower several months before the wedding, at the bridesmaid's luncheon several days before, then as a table arrangement for the wedding reception. And if the colors are considered carefully, the same arrangement can endure in the couple's living room for many years.

Because they can be made ahead of time—unlike fresh arrangements, which must be prepared at the last minute—silks are ideal for those couples who want to save money by doing their own flowers. (Having all or most of the flowers finished early can surely relieve some of the pre-wedding pressure.)

Another advantage to using silks is the better selection of flower varieties. Silks, of course, do not have seasonal limitations, as do fresh flowers. If it grows in nature, chances are you can find it in silk, and, thus, you do not need to wait until it blooms—only until the craft store opens. Who says you can't have daffodils in December?

AUTUMN GREENERY

DESIGN:
ALYCE NADEAU

Sometimes, the container itself can inspire a design. This spiky assortment of subtly colored flowers and greenery echoes the colors and design of a gorgeous Chinese vase. It's beautiful on a table in a room with a cathedral ceiling.

WHAT TO DO

Search your house for an interesting container (preferably with a design) and work from there. Cut floral foam to fit inside the chosen container so that it extends about 2 inches (5 cm) above the rim of the container. This allows for the insertion of a larger number of stems, and thus creates a fuller look. Secure the foam with floral tape. Cover the surface of the foam with sheet moss attached with floral pins.

For this design, attach floral picks to pieces of silk ficus greenery and insert into foam to establish the dimensions of the design. Do the same for three stems of silk bells of Ireland, five silk grapevine stalks, and three stems of dried la rosa (a plant that looks like cattails), forming a pyramid shape. Fill in between the greenery with silk onion grass.

Separate and insert blue-budded stems and bunches of colored-berry stems into the design, concentrating these materials around the upper edge of the design. Separate a dusty miller bush into individual stems, attach floral picks to several stems, and insert into the center of the arrangement. The dusty miller plant should radiate from the base of the design. Attach floral picks to white poppies and add throughout the design—these flowers will provide balance. Cut apart a bunch of philodendron, pick together in groups of three, and insert into foam. The last ingredient is dried weeds! Give them a chance, as these weeds give the design "lift" and make it more natural looking.

HYDRANGEA TOPIARY

DESIGN: MICHELLE KOEPKE WEST

The stately beauty of this topiary is a wonderful addition to any entryway or foyer.

WHAT TO DO

Select an unusual limb from the forest or cut off the hook of an unfinished twisted walking stick. This will serve as the topiary stem. Here, a 42-inch (106.5 cm) stick was used, though you can make your topiary as short or as tall as you like.

Choose a terra-cotta pot as the base—this 10-inch (25.5 cm) diameter pot has a relief design. Trim a piece (or several pieces, if necessary) of polystyrene to fit into the base of the pot and hot-glue in place. Cover the top of the foam with loose pieces of mountain moss. Carefully use the stem to create a hole about two-thirds of the way into center of the covered foam. When a deep enough hole is formed, remove the stem, squirt hot glue into the hole, and reinsert the stem. Allow to dry.

Press an 8-inch (20.5 cm) polystyrene ball on top of the stem. Use a knife to start the hole if necessary and squirt some hot glue inside the ball before attaching to the stem. The stem should go inside the ball about 3 inches (7.5 cm). Pin pieces of green mountain moss to the balls. (Do not use glue to attach the moss, as it will hinder the insertion of flower stems.)

You will need about nine bushes of silk hydrangeas for this topiary. Cut the stems from seven of the bushes into 8-inch (20.5 cm) lengths (including the bloom head and stem). Either put floral picks on the ends of the flowers or use a dab of hot glue on the flower ends before you insert them.

Begin to insert the hydrangeas. You do not need to start at any particular point and it is fine to leave small gaps where leaves and mountain moss are visible. Save two full bushes, push them into the base pot on either side of the stick, and fluff them out so that they completely surround the bottom of the stem.

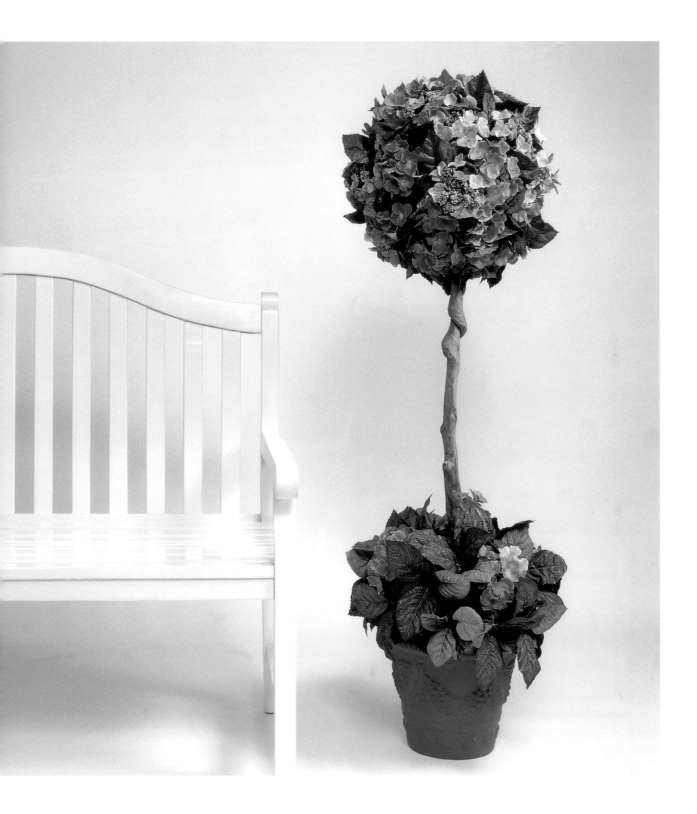

A UTUMN

POMEGRANATE ARRANGEMENT

DESIGN: JOANN HANDLEY

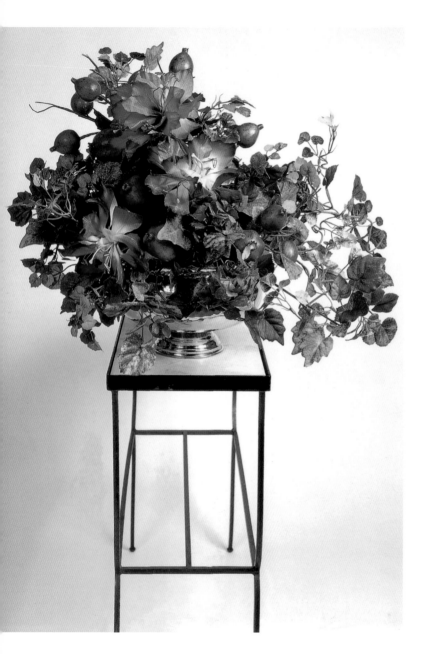

Resist the urge to perfectly proportion your floral creations. Sometimes, a little chaos makes for the most captivating designs. Red pomegranates and amaryllis bring out fall greenery in this one—which is wonderfully disorganized.

WHAT TO DO

We've used a 10-inch (25.5 cm) brass container, which dresses up the arrangement somewhat. Cut a piece of floral foam to fit inside the container and secure tightly with floral tape. Cover with Spanish moss and attach moss with floral pins.

Cut apart one large fall greenery bush into smaller bunches, attach floral picks to the ends, and insert the greenery at angles throughout the container. The greenery will determine the shape; this designer has skewed the flowers (and focal point) slightly to one side and allowed the greenery to extend out of the container on the other side.

Cut three amaryllis stems to varying lengths: about 10 inches (25.5 cm) for the back flower, 8 inches (20.5 cm) for the center flower, and 6 inches (15 cm) for the front flower. Position and insert the flowers. Repeat with the pomegranate stems: cut to 11 inches (28 cm) for the back stem, 6 inches (15 cm) for the middle stems, and 4 inches (10 cm) for the front stems. After the amaryllis and pomegranates are in place, insert greenery into the arrangement where needed.

VEGETABLE BASKET

DESIGN: JOANN HANDLEY

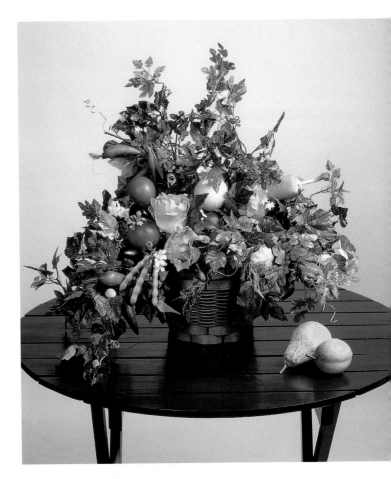

In this lush vegetable basket, the designer has carefully considered the balance and proportion of the overall arrangement; it has a pleasing symmetry, while still conveying the feel of overflowing produce. By intertwining foliage with the vegetables (in contrast to the bowl of vegetables on page 82), this piece evokes vegetables in an unpicked state.

WHAT TO DO

The selection of artificial vegetables out there is astonishing; if you can grow it in your garden, chances are, you can find it at the silk flower supplier. Vegetable swags—three or four or more vegetables connected at the stems—are available and make arrangements such as this one much easier. And there is nothing to prevent you from separating them when you get them home or snipping off a vegetable or two if it doesn't suit the piece.

This basket is a 7 x 8-inch (18 x 20.5 cm) hanging basket that will also rest on a flat surface, and can thus be used as a table arrangement or a wall hanging. Fill the basket with floral foam and secure with floral tape or hot glue.

Attach sprigs of variegated ivy to each other with floral picks—you will need one large bush—and begin to insert the ivy into the foam. The ivy will create the outline of the arrangement, so take care

to place it carefully. Make sure some sprigs are spilling over the edge of the basket.

Following the lines of the ivy, insert the vegetables. Place the largest one at the center, and nestle the rest in the ivy, again allowing some of the vegetables to spill over the basket. To attach them, use floral picks, floral pins, or hot glue, whichever method is easier for the particular piece. (For example, the carrot will need to have a floral pick glued to the bottom edge and inserted into the foam.)

AUTUMN

TOUCH OF BLUE SWAG

DESIGN: BERNICE RICE

Shades of subtle blue—silk clematis and portulaca—show up nicely against a spriggy eucalyptus backdrop and tufts of red blazing stars.

WHAT TO DO

Begin with a grapevine swag. Use glue and wire to attach a 4-inch (10 cm) block of floral foam to the center of the swag base. Use a knife to trim the foam so that it fits the swag. Hot-glue stems of eucalyptus to the grapevine, beginning in the center and working outward on each side. Make sure you tuck each stem under the other stems as you work. Spread the stems out so that they are evenly spaced.

Attach floral picks to the ends of bunches of red blazing stars and begin to insert them into the floral foam. As you place the flowers, you will probably want to snip some of the shorter stems off to create a nicer shape. Take four stems of light blue clematis (about 6 inches or 15 cm long) and insert them into the foam. Place these flowers carefully, since they will be focal points of the design.

Two 3-inch (7.5 cm) stems of portulaca go in next—in the very center of the swag. Try to include a closed portulaca bloom or two for authenticity. Nestle white plum blossoms around the central portulacas and insert into the foam.

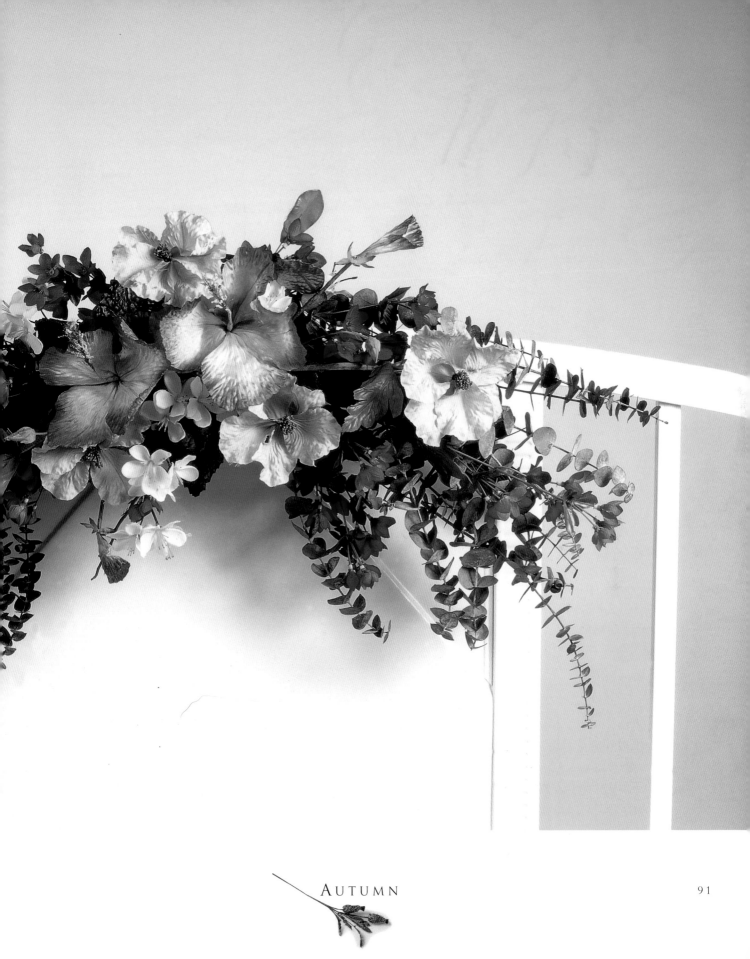

AUTUMN

DIAMOND-SHAPED WREATH

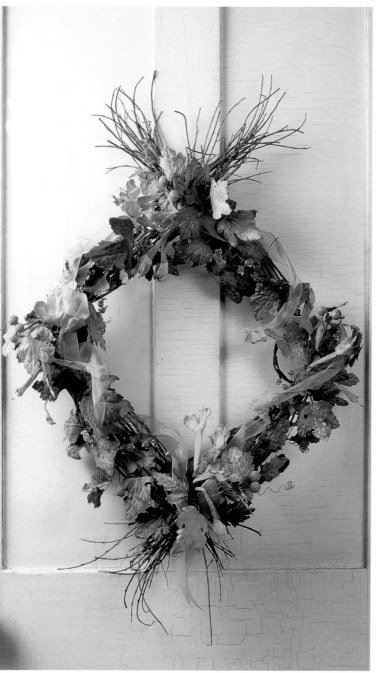

DESIGN: A L Y C E N A D E A U

Who says wreaths should be round? This wreath can be diamond-shaped or square, depending on your decor—or your mood. Including both green and "turning" grape leaves is a nice touch and the chiffon ribbon softens the design for an agreeable effect.

WHAT TO DO

This wreath base was created by joining two twig bases at right angles. First, use wire to gather together the spread ends of the twig bases. Cross the ends and wire them together so that twigs stick out on either side.

Pull clusters of grape leaves from a bunch, then use chenille wire to connect the grape-leaf bunches to the base. Space the leaves evenly, with one bunch at each of the four corners and one along the center of each side. Stretch and bend the leaves for a natural look.

Detach four bunches of fall-colored grape leaves and grapes from the main stem. Spread, curl, and wire the leaves across the corners to contrast with the green leaves. (Note that all bunches of materials point in the same direction.)

Separate bittersweet-berry clusters and wire one cluster in the center of each side of the wreath base. Hot-glue a cluster of trumpet-vine blossoms in each corner and single grape leaves along the base to cover chenille stems. Hot-glue green chiffon ribbon around the entire wreath.

FESTOON WITH CHILI PEPPERS

DESIGN:
FRED TYSON GAYLOR

If you are a pushover for dried culinary arrangements, reserve a space in your kitchen for a silk one. This festoon is generously adorned with artificial chili peppers nestled among colorful flowers and springeri, or asparagus fern.

WHAT TO DO

Cut a festoon shape from ½-inch (1.5 cm) plywood to the desired dimensions with a jigsaw. Drill holes on each side for hanging points. Paint, if desired; the wooden base will not show, so painting is optional. Cut pieces of polystyrene to cover one side of the plywood cutout. Attach polystyrene with construction adhesive from a caulking gun. The polystyrene should be very sturdily attached.

Cover the entire surface of the polystyrene with silk springeri, using hot glue to attach the foliage. Allow sprigs of the springeri to droop down from both sides of the festoon. Attach peppers to floral

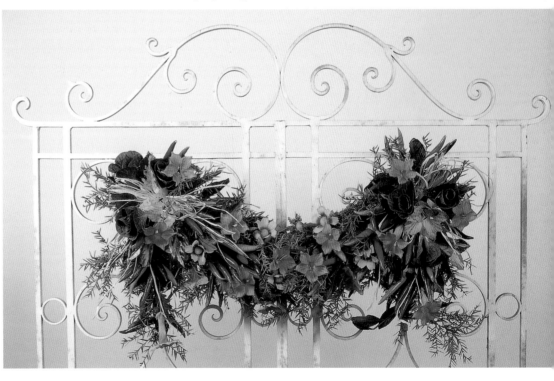

picks—you might need to hot-glue the picks directly to the ends of the peppers—and insert into the polystyrene at an angle, concentrating most of the peppers on the sides of the arrangement. Dribble hot glue on the ends of the picks before inserting them.

Next, pick orange trumpet lilies and yellow flowers of any variety (these are in the daisy family) and insert into the polystyrene, nestling flowers around the peppers. Make two bows from strands of raffia, secure with wire, and attach to the "hanging points" of the festoon. Hot-glue miniature lettuce leaves and caladium leaves around the bows on both sides. Glue bits of sheet moss on any open spaces.

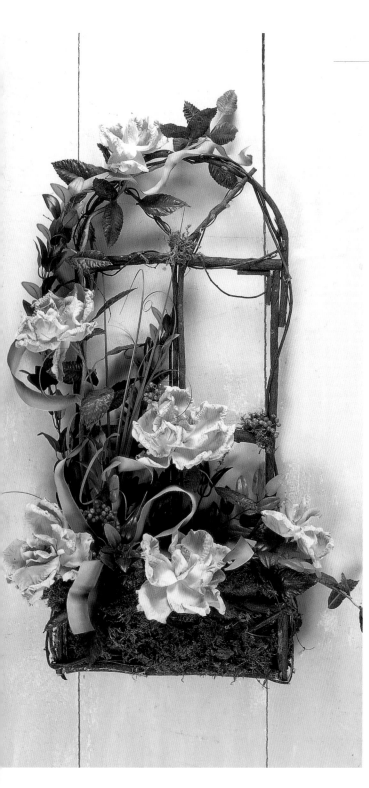

ANTIQUE ROSE BASKET

DESIGN:
CYNTHIA GILLOOLY

This hanging grapevine basket arrangement features dried-look wild roses mingled with myrtle plant and onion grass and looks fantastic on a door, a gate, or even propped up against a wall.

WHAT TO DO

Begin with a hanging grapevine basket; they come in a variety of shapes and sizes. Cut a piece of floral foam to fit snugly inside the basket, cover the block with sheet moss, and secure the moss with hot glue or floral pins. Press the moss-covered foam into the basket.

Attach picks to the ends of several bunches of onion grass and myrtle leaves and insert the picks into the basket, concentrating the greenery in the back left corner. Attach one of the antique roses to a floral pick and insert into the base just under the concentrated greenery. The rest of the roses will be attached to the basket with hot glue; hot-glue three roses around the outside edge of the basket.

Finish by winding and hot-gluing several roses and myrtle-plant stems up the left edge of the basket hanger. Hot-glue small pieces of sheet moss and bunches of pepperberries throughout the basket as desired. Make a bow with a piece of ribbon (about 2 yards or 1.8 m), leaving a very long tail on one end. Attach the bow to the basket with floral pins and curl the long tail up the left side of basket, hot-gluing at intervals to secure.

GARDEN WREATH

DESIGN:
MARDI LETSON

Composed of an inviting combination of bright sunflowers and early fall produce, this autumn wreath beams with the deep colors of the season. A selection of silk leaves—just beginning to change their colors—completes the composition.

WHAT TO DO

This designer has used a grapevine wreath, which indeed works very well; feel free to substitute straw or any other natural wreath base. Begin by winding silk fall leaves (they often come as a garland) around the entire wreath. Use hot glue as needed to secure the leaves. Notice that some of the leaves are situated so as to appear to be growing off the side of the wreath. Next, hot-glue sprigs of ivy to the wreath, filling in open spaces.

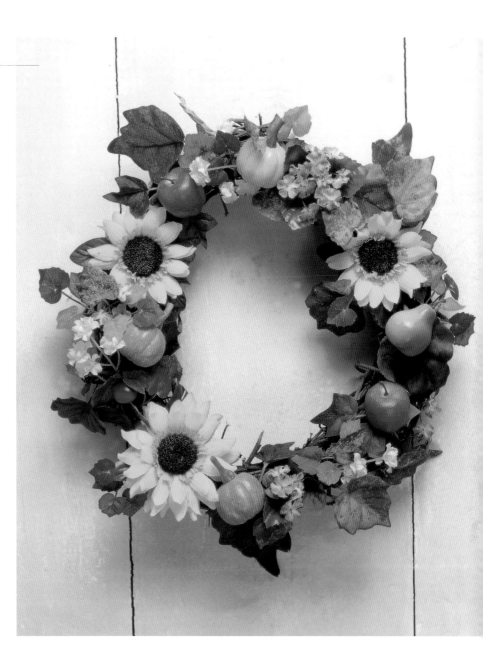

The sunflowers are central to the design, so take care to place them carefully. Use groups of odd numbers of flowers to avoid a blocky look; here, the designer has chosen three; you might want to use five if your sunflowers are smaller. Hot-glue the sunflowers to the wreath.

Hot-glue miniature fruit—pumpkins, squash, pears, apples, and cranberries—to the wreath, then fill in any spaces with orange and yellow wild flowers.

RAFFIA WITCH

DESIGN:
E L I Z A B E T H P A Y N E

Nevermind the old adage that witches are ugly. Use any silk materials you choose to create a lovely witch that celebrates the ghoulishness of the season with taste.

WHAT TO DO

Raffia witches, equipped with brooms and ready to embellish, are available at most craft and hobby stores. This one is 3 ½ feet (1 m) long and is the perfect size for a door. Begin with the ribbon. You will need about 3 ½ yards (3.2 m) of orange woven ribbon. Cut a piece to fit around the rim of the witch's hat and glue into place. Use the rest to make a large, airy bow.

Place two silk ivy branches on top of the broom and attach with wire or hot glue. Layer on the rest of the materials in the following order and wire to the handle of the broom: one cattail branch, three stems of dried wheat, one large coneflower branch, one orange chrysanthemum stem, and one rust-colored rose. (Sounds like the makings of a good witch's brew.) The rose should go just under where the bow will be. Last, attach the bow to the top of the broom with hot glue or wire, making sure the bow completely covers the wire used to attach the rest of the flowers.

MAGNOLIA ENCHANTMENT

DESIGN:
JOANN HANDLEY

Although magnolias are decidedly spring or early summer flowers, this is a good example of how you can create a very autumnal-looking arrangement with spring materials. Magnolias are among the most handsome and authentic-looking silk blooms, and for this reason are a favorite with silk flower designers. Here, the designer makes use of a contemporary vase and snowberry stems to create a pleasingly dramatic arrangement.

WHAT TO DO

Begin by securing floral foam in the vase, either with hot glue or floral tape. Cover the floral foam with Spanish moss.

Cut three large burgundy magnolia stems in staggered sizes: about 10 inches (25.5 cm) for the back flower, 8 inches (20.5 cm) for the center one, and 6 inches (15 cm) for the front or focal flower. Insert the stems into the foam. Next, cut several stems of silk dogwood flowers to lengths between 4 inches (10 cm) and 12 inches (30.5 cm)—enough to create a balance of flowers—and insert them between the magnolias.

Tie a knot on the end of four pieces of cording in colors to complement the flowers—forest green and burgundy. Attach a floral pick to one end of each piece and insert into the floral foam on each side. Remove the berries from two snowberry sprays.

The diagonal sweep of the snowberry stems from top left to bottom right supplies much of the piece's flair. To achieve this, curve one bush upward and the other one downward and insert them into the foam on both sides. Finish by inserting magnolia leaves as needed to fill in any extra space.

GOLDEN TOPIARY

DESIGN: TERRY TAYLOR

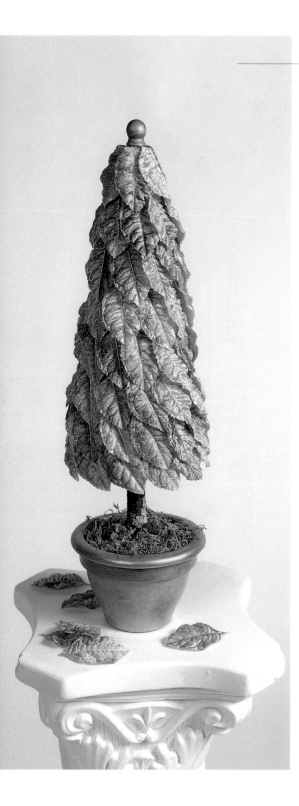

This designer has taken advantage of the soft, elegant look of vel-vet millinery leaves and created a lovely fall topiary. Try to find a lichen-covered branch for this project, as the design benefits from the addition of natural materials.

WHAT TO DO

First, paint a 4-inch (10 cm) clay pot and a wooden newel knob (available at craft stores in the wooden parts or doll house section) with gold acrylic paint and allow to dry.

Carve a block of floral foam to fit inside the pot and use your hot-glue gun to anchor the block in the pot. You can also fill the pot with plaster for more stability. If so, mix the plaster according to the manufacturer's directions. Use masking tape to cover the drainage hole in the bottom of the pot. Pour in the mixed plaster and center the tree branch upright in the pot. Allow to set up.

Make a small hole in the bottom of a polystyrene cone with a knife or other sharp object. Position the cone on the branch and secure with hot glue. Begin gluing leaves—one at a time—to the lower edge of the cone, overlapping each leaf slightly to hide the polystyrene base. (You may want to experiment with leaf place-ment first, either gluing the leaves point-end-down in a straight line or angling them slightly.) Continue gluing leaves up the cone in a circular fashion. Overlap each row to cover the polystyrene base. You will probably need about 50 to 60 millinery leaves for this topiary.

When you are almost to the top row, use a pencil to make a hole in the top of the cone to fit the newel knob in to. Continue glu-ing leaves up to and slightly over the top of the topiary. Place a dab of hot glue into the hole and insert the newel knob.

EUCALYPTUS CENTERPIECE

DESIGN: JOAN NAYLOR

In this piece, the designer has combined enchanting burgundy-tipped pink roses with dried natural materials and the result is a bewitching centerpiece perfect for a fall dinner gathering.

WHAT TO DO

Begin with an artificial evergreen base; shape the stems so that they have a natural look. Wire or hot-glue candle holders to the center of the base. This designer has hot-glued all of the materials into the base, but you can also use floral picks.

Begin the design by inserting eucalyptus and silver-king artemisia to establish an outline. Then insert the roses, making sure to place several at the base of the candles as focal flowers. To finish, insert the burgundy coxcomb into any spaces that still remain and situate the candles in the holders. (You might want to press some craft clay in the holders first to ensure a snug fit.)

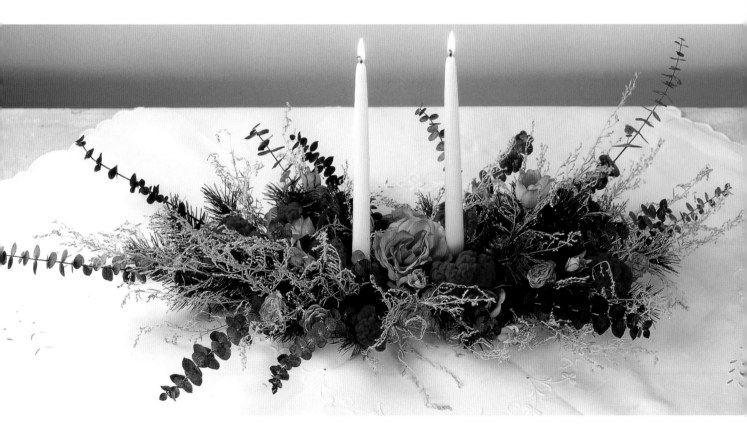

WINTER
WONDERLAND

O WINTER, KING OF INTIMATE DELIGHTS,
FIRE-SIDE ENJOYMENTS, HOME-BORN HAPPINESS,
AND ALL THE COMFORTS THAT THE LOWLY ROOF
OF UNDISTURB'D RETIREMENT, AND THE HOURS
OF LONG UNINTERRUPTED EV'NING, KNOW.

WILLIAM COWPER, *The Task*

Silk flowers can be just what the doctor ordered

amidst midwinter gray.

And while evergreen foliage and scarlet berries

make for delightful floral creations,

one of the great advantages to silk flowers

is that they allow you to cheat a little when it comes to seasonal

flowers. So don't let winter gloom stifle your creativity!

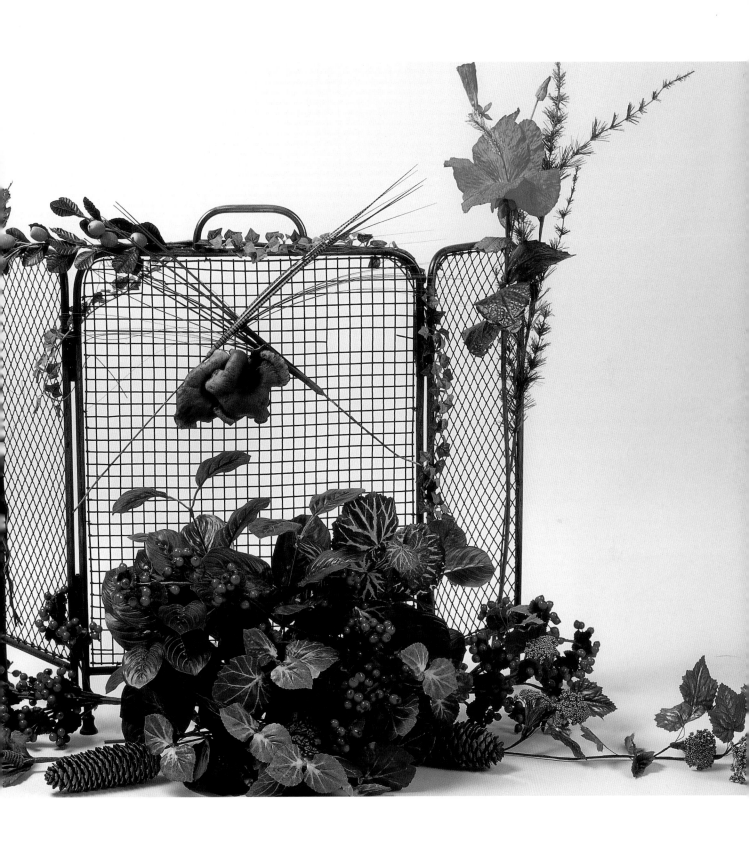

AMARYLLIS ARRANGEMENT

DESIGN: CYNTHIA GILLOOLY

This spectacular holiday arrangement makes use of a natural basket and features dramatic curly willow rising from a bed of lush greenery. Its scale is such that it can easily be positioned in the middle of a large dining table or even on the floor.

WHAT TO DO

The base of this arrangement is a wisteria vine basket. The open weave of the basket allows Spanish moss to tumble through, as well as over the top of, the basket. You will need to cut polystyrene to fit snugly inside the base. Make sure the polystyrene comes all the way to the top of the basket, since the weighty stems will require a good, stable hold. Cover the block of foam with Spanish moss, secure with hot glue, and wedge into the basket.

First, insert the curly willow at the back of the basket. Tape the stems of three large silk amaryllis together, tie them with raffia, and insert them into the center of the foam. Next, add a base of artificial greenery all the way around the amaryllis. (Depending on the greenery you have, you might need to attach floral picks.) Some greenery should be spilling out over the edge of the basket. Nestle lichens and pine cones—which have been attached to floral picks—in between the greenery. Attach gold and red berries to floral picks; insert the gold berries on the left half of the arrangement and red berries on the right side.

Add a generous amount of holiday ribbon for the finishing touch. Cut the ribbon in 1½ foot (.5 m) lengths, fold the lengths in half, pick the two ends together with floral picks, and insert the ribbon into the foam throughout the arrangement.

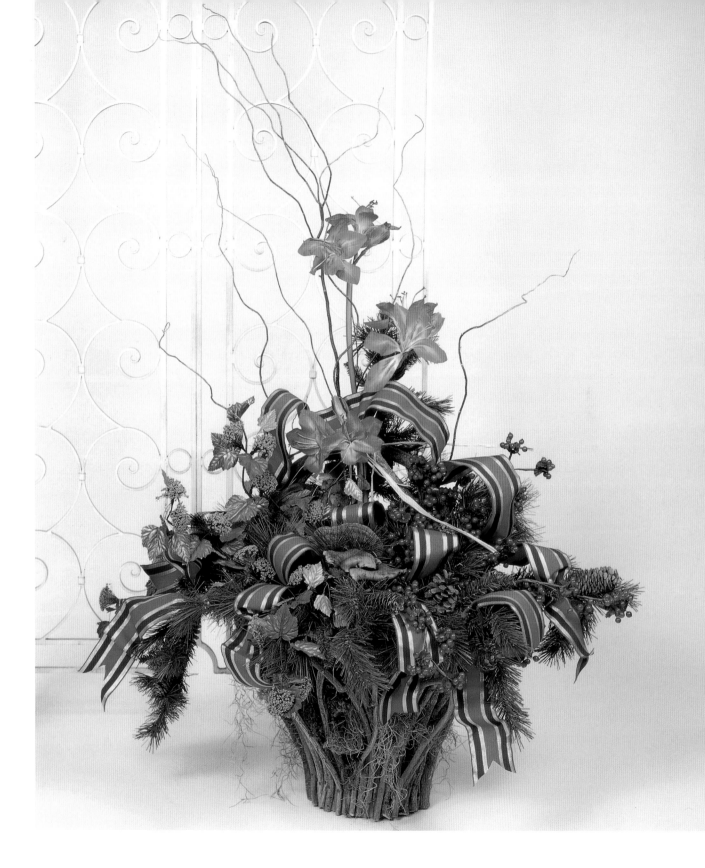

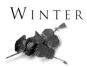

IVY-TWINED ARRANGEMENTS

DESIGN:
J A M I E M C C A B E *(topiary)* & A L Y C E N A D E A U *(birdhouse and watering can)*

Silk ivy is extremely versatile and authentic-looking and will improve the appearance of virtually anything it is wrapped around. A nice feature of ivy designs is that they require only a few items from the craft store. Here are three simple examples.

WHAT TO DO

Watering can: Use wire cutters to cut the hanger from a coat hanger. Bend the remaining wire into a circle with two "stems." Wrap the entire length of the wire with floral tape. Separate the stems, then wrap the connection with floral tape so that the topiary framework will be secure. Position wire frame in the opening of the watering can, allowing the stems to reach into the can, and fill the can with rocks for stability.

Cut several 7-inch (18 cm) pieces of silk ivy and have pieces of floral tape ready to attach the ivy to the frame. Wind the ivy around the frame, using floral tape and hot glue to attach at intervals. Hot-glue single ivy leaves over any visible floral tape or glue remnants. Finish by hot-gluing Spanish moss around the base, encircling the pot with raffia, and tying a bow at the front with streamers hanging down on both sides.

Birdhouse: Buy or make a wooden birdhouse. If desired, apply stain or paint to the birdhouse (in a well-ventilated area). Allow to dry thoroughly. Separate individual grapevine stems and drape stems over the top and the sides of the birdhouse—staple into place in such a manner that the leaves can be bent to hide staples.

Hot-glue extra single leaves wherever necessary to complete the flow of the design. Attach a grapevine heart just below the opening of the birdhouse. A realistic faux bird in the opening or on a perch might also be added, if desired.

Topiary: You can buy this grapevine topiary already assembled in craft stores. If you would like to make your own, form a ball by twisting grapevine pieces together and hot-glue the ball to the edge of a branch. Fill a small basket with floral foam and cover the top of the foam with Spanish moss. Secure the moss with floral pins. Insert and hot-glue the other end of the branch into the foam. (You will probably need to cut an opening for the branch with a craft knife.)

Cut stems of ivy in pieces each several feet long and wind the pieces around the entire topiary form. As you weave each piece, glue each end of the ivy to the topiary. Do not cover the entire form; make sure some of the grapevine is showing through the ivy.

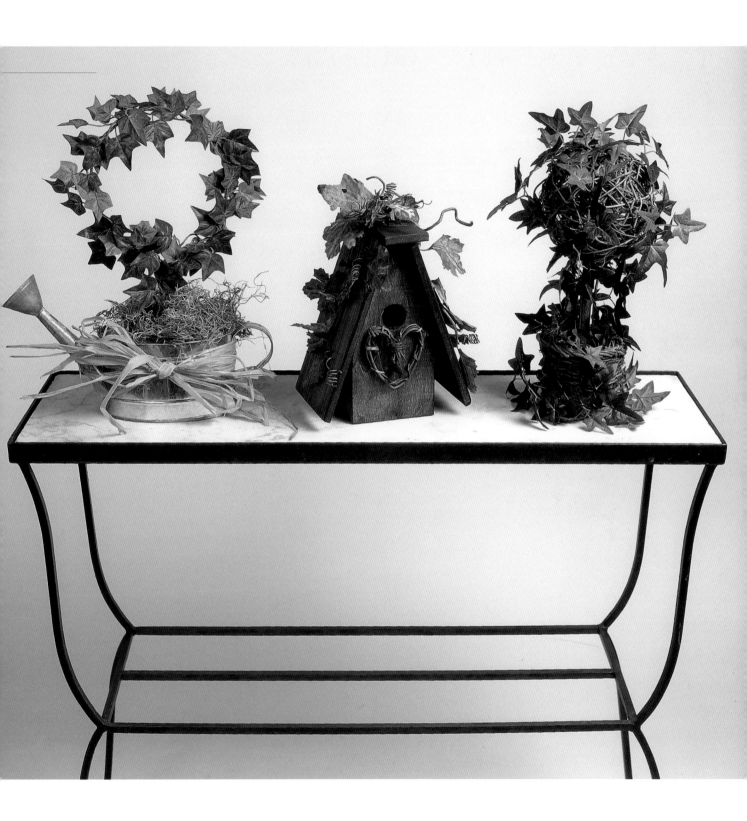

WINTER

IVY WREATH TOPIARY

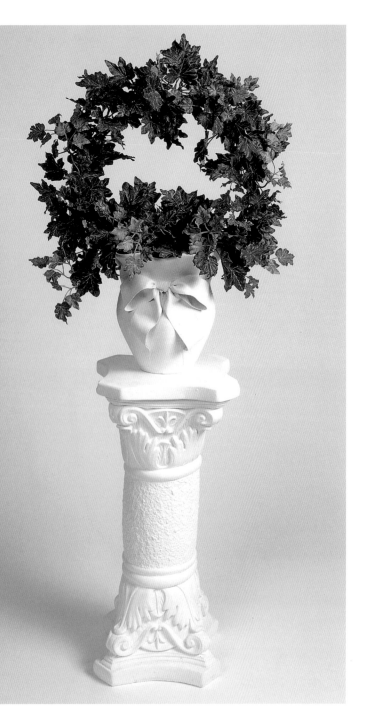

DESIGN:
LOUISE RIDDLE

In this topiary, lush silk ivy, a classic white pot, and an elegant presentation make for a striking, yet simple arrangement.

WHAT TO DO

Fill a decorative pot—this one is 8 inches (20.5 cm) high—with polystyrene. Cut a small trench out of the top of the polystyrene where the metal ring will rest.

Wrap a 10-inch (25.5 cm) metal ring with green floral tape—wire from a coat hanger will work. You will need about 6 feet (1.8 m) of ivy altogether for this arrangement. Use 4 feet (1.2 m) of the ivy to cover the metal ring, securing the ivy in several places with floral wire.

Place the ring of ivy two-thirds of the way into the foam and secure with floral pins and a heavy layer of hot glue. Cover the top of the foam with sheet moss; be particularly careful to cover the area where the metal ring is secured. Cut the remaining ivy into 6-inch (15 cm) lengths and attach to floral picks. Use these pieces to fill the top of the pot. Make sure some of the ivy spills over the edge of the pot.

PAPER-WHITE BULBS

**DESIGN:
CYNTHIA
GILLOOLY**

*Tired of trying to coax your bulbs
into blooming early? Surprise even
the most discerning eye with this
faux-bulb arrangement. It allows
you to have the look of narcissus
bulbs with a fraction of the trouble.*

WHAT TO DO

The bark base can be purchased
already assembled at a floral supply
store or you can make it yourself by
covering a vessel—possibly a card-
board box or plastic container—
with pieces of bark and hot-gluing
moss to the edges.

Wedge and hot-glue a piece of flo-
ral foam into the container and
cover the entire surface of the foam
with sheet moss. You can find "silk"
bulbs at most craft stores that carry
silk supplies. Simply insert the stems
of the silk flowers at varying
heights—you might want to trim
off a few stems first—into the base

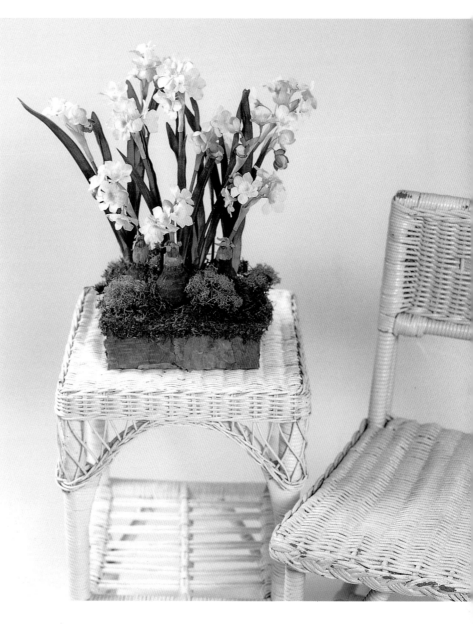

of the bulb and hot-glue the base of the bulb to moss. Finish the arrangement by hot-glu-
ing reindeer moss at the base of the bulbs to create a more earthy effect. Feel free to substi-
tute any other bulbing plant.

WINTER

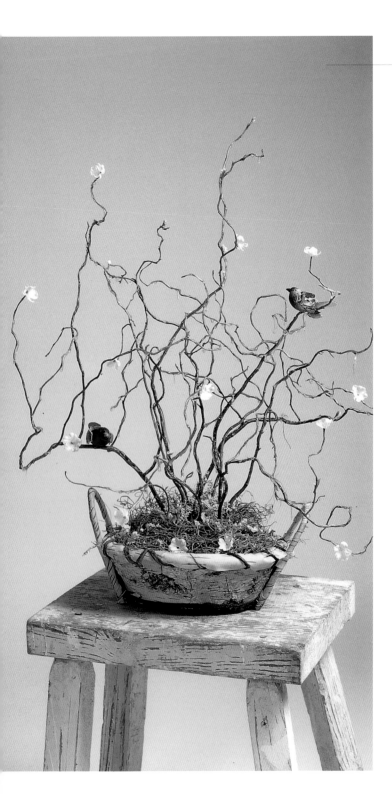

WINTER WILLOW

DESIGN:
JAMIE MCCABE

There is no reason a winter arrangement—in spite of a lack of blooms (or even foliage)—need be uninteresting. Here, the designer has cleverly wielded her glue gun to create the illusion of winter ice on branches.

WHAT TO DO

Fill the birch basket with foam and cover with Spanish moss. Secure the moss with floral pins. Cut curly willow branches slightly larger than is proportionate to the container and arrange branches in the foam so they resemble a growing tree. Place berries under tree branches and glue two birds to branches on either side of the piece. Attach a berry to the beak of one bird.

Dribble hot glue on the branches to create an icy look. Before the glue dries, randomly place white bellflowers on the limbs and glue some additional flowers to the base. Finish off by inserting a small amount of German statice at the base of the limbs.

SILK FLOWERS

ROSE AND OKRA WREATH

DESIGN: JOAN NAYLOR

While this wreath uses a combination of natural and artificial materials, burgundy silk roses are the focal points of the piece. The unusual combination of materials incorporates a wide variety of shapes for an interesting visual texture.

WHAT TO DO

Begin with an artificial greenery wreath base. Bend and shape the branches of the base for a natural look. Glue the mushrooms around the wreath first, as they will be difficult to insert later. Next, place printed ribbon on top of gold ribbon, allowing the edge of the gold ribbon to stick out on one side. Lay the ribbon on the wreath, tuck into the wreath base at even intervals, and use hot glue or floral picks to secure the ribbon.

Spray-paint pine cones gold—sometimes you can find them already painted—and hot-glue the cones to the wreath when they dry completely. Designer Joan Naylor, an expert flower dryer, has used dried okra that she painted burgundy. If you do not have access to dried okra, any similar pod will work just as well. Glue the okra or pods around the wreath. To finish, fill in spaces with silk roses. Make sure to glue the roses both around the outside edge and to the inner circle.

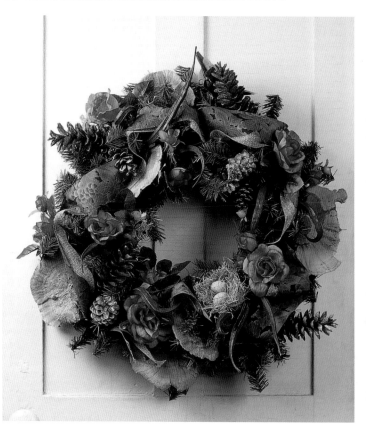

POINSETTIA
TABLE ARRANGEMENT

DESIGN:
A N N E B R I G H T M A N

If your creative spirit resists conventional holiday arrangements, take on the challenge of making one that is at once traditional and unique. In this table arrangement, a bountiful selection of holiday foliage and berries—both artificial and dried—is a perfect backdrop for deep red poinsettias.

WHAT TO DO

Here, we have chosen a three-legged brass container, which creates a formal, festive look. Choose your container and place floral foam 2 inches (5 cm) above the container's edge and secure in place with floral tape. Cover the foam with Spanish moss and attach moss to the foam with floral pins.

To convey the abundant look of the piece, use liberal portions of all the materials. The flowers used here are roses, poinsettias, red holly, gold foliage, red and white berries, and cedar ferns. Make sure you place some flowers deep inside the arrangement to give the arrangement depth, insert the elements at different angles, and use varying stages of flower development.

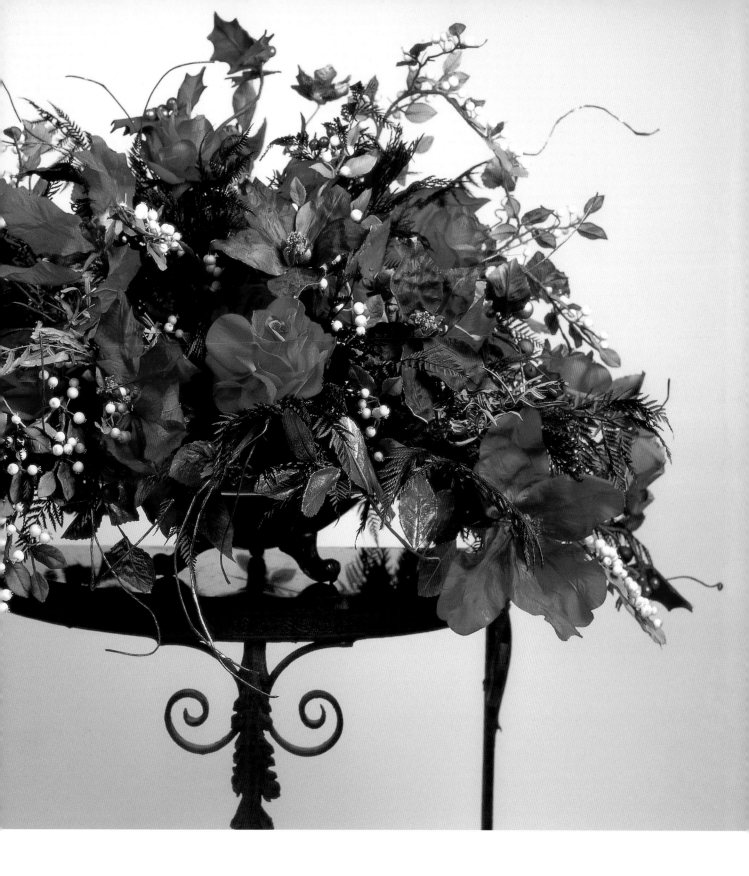

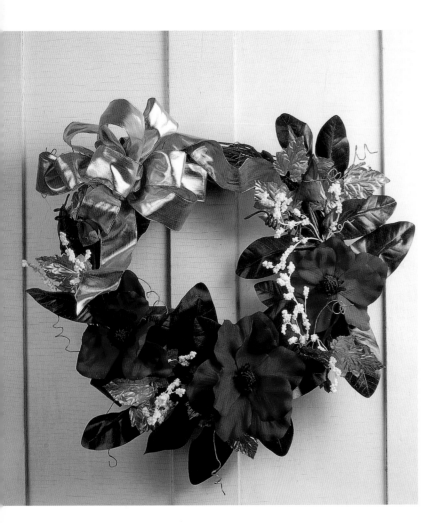

CHRISTMAS SPLENDOR

DESIGN: BERNICE RICE

Since silk-flower decorations can be packed away year after year, silks are the perfect choice for holiday arrangements. Elegant gold ribbon dresses up this simple wreath of burgundy magnolia and white Christmas berries.

WHAT TO DO

Begin with an oval grapevine wreath; this one is 18 inches (45.5 cm) in diameter. Position the wreath so that the side of the oval with the longest dimensions is vertical. Hot-glue a stem of burgundy magnolias (with leaves) to the bottom center of the wreath first, then two magnolias on each side of the central flower. Two magnolia buds are the last flowers to be attached; they go just above the outer magnolia flowers.

Nestle white Christmas berries around each magnolia bloom and hot-glue into place. Hot-glue gold grape leaves at the back of the magnolias. Finish by inserting gold Christmas berries. Take 4 yards (3.6 m) of wired gold ribbon and form a bow. Attach the bow to the upper left corner of the wreath with floral wire. Crinkle the tails of the bow and hot-glue each out to the side of the bow.

BOXWOOD
HOLIDAY TREE

DESIGN:
CYNTHIA GILLOOLY

This frosted silk-boxwood arrangement adds a touch of elegance to the holiday season and is extremely easy to make. When the season changes, replace the camellia berries with silk roses and sprigs of baby's breath and voila!— a year-round arrangement.

WHAT TO DO

To make the base, dip a sponge in white paint, dab the sponge over the surface of a terra-cotta pot, and allow to dry. Wedge a foam block inside the pot, stick three or four wooden floral picks into the foam and glue into place. Position a foam cylinder on top of the picks, making sure the two foam pieces fit snugly together. You can apply hot glue for extra support.

Use floral picks to combine bunches of frosted silk boxwood and cover the surface of the foam cylinder with the picked boxwood. Use floral pins to attach a single piece of ribbon at intervals throughout the arrangement. Spray-paint natural camellia berries gold and insert into design. (You could also use silver ribbon and spray-paint berries silver.)

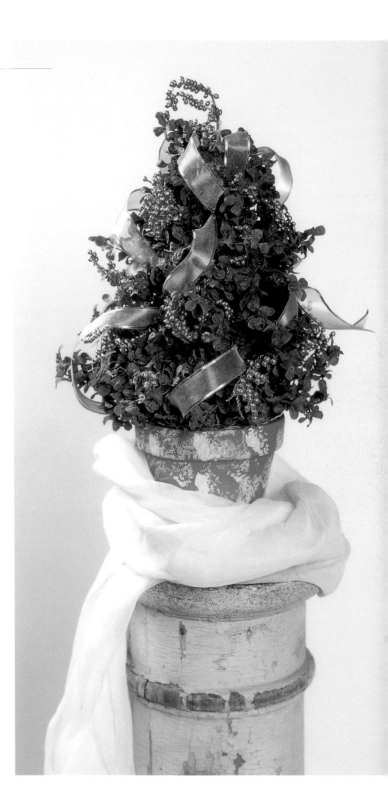

THE PAMPERED SILKWORM

Much goes into making silk, the fabric that has been synonymous with fashion, status, and wealth for centuries. Silk is actually made by the larvae of a moth, called Bombyx mori, *which lives on the leaves of the mulberry tree.*

First, eggs are laid by an adult moth, who lays about 350 to 500 eggs, then dies shortly thereafter. Eventually, the "worm" hatches from the eggs and begins to feed on the mulberry leaves. At this stage, it consumes about 50 times its weight in leaves. With these raw materials, the silkworm spins the valuable silk.

In three to four days, the caterpillar can completely cover itself in a house, or cocoon, of self-spun silk. In two weeks, it changes into a moth. On silk farms, most caterpillars never become moths, since the cocoons are plunged into hot water, then hot ovens, and the caterpillar dies. However, some moths are preserved, so that they can mate and lay eggs, thus beginning the process again.

Silk farmers have perfected the art of their trade and now know exactly what to do to create silk fibers effectively and efficiently. Silkworms are quite finicky. They cannot tolerate loud sounds or strong odors, or even the smell of smoke. They must be kept at a very exact temperature, and must have plenty of air circulation. (Some even claim a thunderstorm can scare the worms into ceasing their spinning.)

SILK FLOWERS

SOUTHWEST SUNRISE

DESIGN:
MARGARET SHOOK

Winter doesn't mean pine cones and holly leaves for everyone. Here's an untraditional winter foliage arrangement.

WHAT TO DO

You will need a small or container or basket, preferably one colored in warm tones. Fill the container with floral foam and secure the foam with hot glue or floral tape.

Artificial cacti are available in a number of varieties at craft supply stores. Chose several varieties to create an interesting piece. Hot-glue the tallest cactus (this one is saguaro) to one side in the back, a medium-sized cactus (prickly pear) to the center, and a shorter cactus (aloe) to the very front, opposite the tallest. Cut the stems of two lupine flowers and insert in the back; they should stand slightly taller than the tallest cactus. Cover any exposed foam with blue star flowers and dried silver-king artemisia. Wrap colored raffia around the container and tie into a bow.

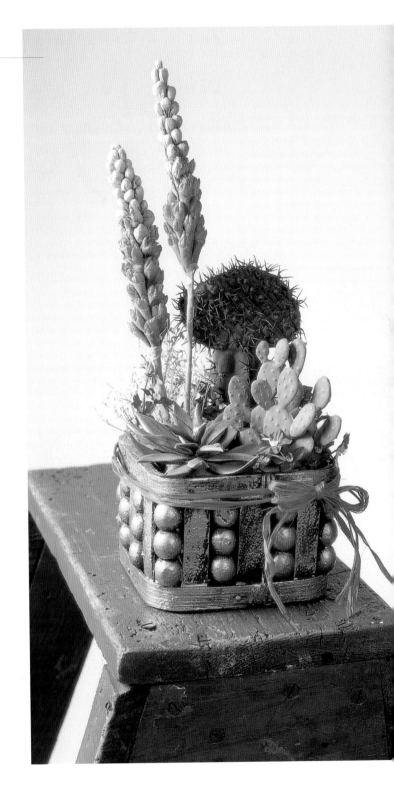

CLASSIC WINTER WREATH

DESIGN: TERRY TAYLOR

Exquisitely refined millinery leaves in creamy white with just a hint of green and a simple strand of white pearls are all you need for this understated little wreath. Sometimes less is more.

WHAT TO DO

Begin your wreath by experimenting with leaf placement. You may wish to angle leaves slightly when covering the base, or you can glue them on in straight rows.

The design in the photo uses a 2-inch (30.5 cm) polystyrene wreath base— use any size that suits your purposes. Glue leaves, overlapping slightly to cover the base, to the inner diameter of the wreath. Glue additional leaves, again overlapping, to the outer diameter of the wreath base. Determine whether you will need one or two rows of leaves on the outer surface of the wreath. Overlap leaves slightly to cover the front of the wreath.

You may elect to leave the back side of the wreath uncovered. This will depend on whether you intend for the wreath to be seen on both sides at once. Determine the point where you wish to place your wreath hanger. Bend a 3-inch (7.5 cm) length of floral wire into a "U" shape and gently push it into the back top portion of the wreath. Remove it, apply hot glue, and reinsert.

Twine 2 yards (1.8 m) of pearl roping around the wreath, beginning at any point on the back. Glue the end of the pearl rope to the back and simply twine the rope around the wreath.

SMALL
SILK
CREATIONS

W hen your hands are itching

to make something, but you don't have

the time or the money to invest

in a full-scale arrangment,

try a small silk-flower project.

Because they last forever, your scraps

(leftover blooms, leaves, and so forth)

can turn into beautiful

(albeit small) creations.

RUSTIC NAPKIN HOLDERS

DESIGN:
MARDI LETSON

These silk flower napkin holders add a soft, country look to a place setting and make a unique and useful gift—possibly for a wedding or a housewarming.

WHAT TO DO

You will need a grapevine napkin ring holder. These are available at craft stores and are very inexpensive. You can also make them by winding pieces of grapevine into circles, tucking the ends behind each other, and securing with hot glue, if necessary.

We have used miniature silk roses and pieces of latex hydrangeas, but feel free to choose any flowers or foliage that match your decor. Hot-glue the flowers to one side of the grapevine circles. When the glue has dried completely, wind Spanish moss around the flowers. You might want to use a small amount of hot glue to secure the moss in spots.

MINIATURE ROSE BARRETTES

DESIGN: JOAN NAYLOR

Dainty silk roses in a variety of colors dress up simple hair barrettes. Use pansies, sunflowers, or any number of silk blooms to embellish all sorts of hair accessories.

WHAT TO DO

You can buy metal barrette bases at any craft store (they are very inexpensive) or use an old barrette you have lying around. Simply hot-glue the silk materials to the barrette base, starting with the leaves, then the miniature roses. Take care to let the leaves dry thoroughly before you apply the flowers.

Small silk flowers can be hot-glued to virtually anything (such as picture frames, headbands, and so forth) to add a decorative touch—use your imagination.

SILK FLOWERS

SMALL SILKS

DECORATED CANDLES

DESIGN: LOUISE RIDDLE

These handsome Victorian candles are a great (and simple) way to create striking decorations—and to use up leftover materials. Try all sorts of candles and see how different each one will be!

WHAT TO DO

First, choose the candles you want to decorate; there is a wide variety available, so put your imagination to work. Position silk flowers, ribbons, and decorative findings, such as buttons and charms, either on the candles or on any flat surface. You will want to experiment with placement. Once you have decided on a design, attach the materials with a hot-glue gun.

CLAY HEART POCKET

DESIGN: LOUISE RIDDLE

This adorable little arrangement, nestled in a lovely handmade clay container, is ideal in a child's room or small nook.

WHAT TO DO

To make the clay pocket, use a rolling pin to roll out pink oven-bake clay to a ¼-inch (.5 cm) thickness. Arrange pieces of lace (the more open the weave, the better) on top of the clay, and roll the lace into the clay. Carefully pull the lace off—the impression will remain on the clay.

Cut out two heart shapes from the clay with cookie cutters. Place the clay hearts back to back and carefully work the clay together along the sides. Leave the top open and place aluminum foil inside to form a "pocket." Make two ⅛-inch (.3 cm) holes in the back of the pocket. Bake according to the manufacturer's instructions and let cool.

You will need about 24 inches (61 cm) of French ribbon. Tie a bow in the middle of the ribbon and run the ends of the ribbon through the holes in the pocket; tie knots in the ribbon to keep the ends from slipping out. Make a wash of one part white acrylic paint and two parts water and apply to pocket. The paint should be thin enough to run into the lace design. Wipe off excess paint and let dry.

Arrange carnations, violets, and daisies in the pocket. Using a hot-glue gun, apply enough glue around the stems to hold them securely in place. (Floral foam is not necessary, since the pocket hole should be small enough to hold the flowers in place until hot glue can be applied.)

VICTORIAN EGG

DESIGN: LOUISE RIDDLE

You'll amaze yourself with what you can create with silk flowers, a few simple tools, and a healthy imagination. An egg adorned with silk flowers makes a wonderful gift and is guaranteed to be a conversation piece.

WHAT TO DO

You can buy clean eggs in some craft stores and through mail-order catalogs. If you want to clean your own egg, puncture small holes in one end with a large needle or ceramic cleaning tool. Carefully enlarge the holes. Use your mouth, a straw, or an egg-blowing device to remove the contents of the egg. Rinse well with warm water. If possible, allow the egg to dry for several days.

Apply two coats of blue acrylic paint to the clean egg and allow to dry. Center and glue ⅛-inch (.3 cm) ribbon around the egg, making sure the holes are covered. Glue leaves along the top of the ribbon as a base for the silk flowers. Finally, glue flowers to the egg in the desired pattern; here, the designer has used violets, rosebuds, delphiniums, and a few miniature berries. To finish, tie a shoestring bow with the ribbon and glue on the egg.

SMALL SILKS

CONTRIBUTING DESIGNERS

CATHY LYDA BARNHARDT is in charge of the floral department at Biltmore House in Asheville, North Carolina, the largest private home in North America. Her specialty is creating floral designs that concentrate on texture and depth.

ANNE BRIGHTMAN is a Welsh-born designer who developed her skills in floral arts at Biltmore House in Asheville, North Carolina. For nine years, she has designed and assembled floral arrangements displayed throughout the estate.

FRED TYSON GAYLOR, formerly head of the design department at Hanford's Creations in Charlotte, North Carolina, now serves as a design consultant and conducts seminars for the industry. He lives in Concord, North Carolina.

CYNTHIA GILLOOLY owns The Golden Cricket, a floral design studio in Asheville, North Carolina, where she also teaches classes. She is known for her unique floral designs and her good-humored creative eye.

JOANN HANDLEY recently relocated to Asheville, North Carolina, from Sarasota, Florida, where she owned and operated her own interior design store. JoAnn has had a lifelong passion for floral design and is currently the floral manager at Ben Franklin Crafts in Asheville, North Carolina.

MARDI LETSON is a social worker who lives in Asheville, North Carolina, with her husband, Kellett, and her dogs, Moses and Shelby. She's an avid gardener who enjoys working with flowers—even those that did not grow in her backyard.

JAMIE MCCABE is a free-lance floral designer who lives in Hendersonville, North Carolina. She has used fresh, dried, and silk flowers for 20 years as a medium for her artistic expression.

ALYCE NADEAU lives in Lansing, North Carolina, and is the author of *Making & Selling Herbal Crafts* (Sterling/Lark, 1995). Past president of the North Carolina Herb Association, Alyce conducts herb classes, creates herbal weddings, and markets her handcrafted herbal creations at farmer's markets, juried craft shows, and through her business, Goldenrod Mountain Herbs.

JOAN NAYLOR owns and operates Rocky Creek Farm Flower Shop in Barnardsville, North Carolina, where she grows and dries a wide variety of flowers and herbs. She enjoys doing weddings and garden tours, as well as teaching classes and seminars.

ELIZABETH PAYNE, owner and operator of Onion Knob Herbs, lives in a 200-year-old log home in Taylorsville, North Carolina. Elizabeth raises more than 200 different herbs and everlastings for her floral design work. She also teaches craft classes.

BERNICE RICE, who lives in Swannanoa, North Carolina, is a self-taught crafter. She has worked with florals for many years and uses a variety of materials to create unique designs.

LOUISE RIDDLE lives in Weaverville, North Carolina. She is the manager of Jo-Belles, a craft store in Swannanoa, North Carolina, and has been involved in crafts for over 30 years. Flowers are her favorite medium for all types of crafts projects.

MARGARET SHOOK is a retired commercial photographer who lives in Asheville, North Carolina. She enjoys creating decorative items for each season using silk, fresh, and dried flowers. She specializes in the design and photography of artemisia tree arrangements.

TERRY TAYLOR specializes in creating art for the garden using the pique-assiette, or shard art, technique. Terry is known for his willingness to try any craft—and does a fabulous job at whatever he tries. He collects, creates, and carves from his home in Asheville, North Carolina.

MICHELLE KOEPKE WEST has an associate degree in commercial art and advertising, though she finds three-dimensional art more exciting. She has been a floral designer for 10 years and is currently employed at Jo-Belles in Swannanoa, North Carolina.

HOPE WRIGHT works at the Golden Cricket in Asheville, North Carolina. She has been involved in floral design for 10 years. Her passion is for gardening and she prefers a natural approach to flower arranging. She grows and dries a wide variety of flowers to make everlasting wreaths and baskets.

PROJECT INDEX

SUBJECT INDEX